RETAIL FICTIONS

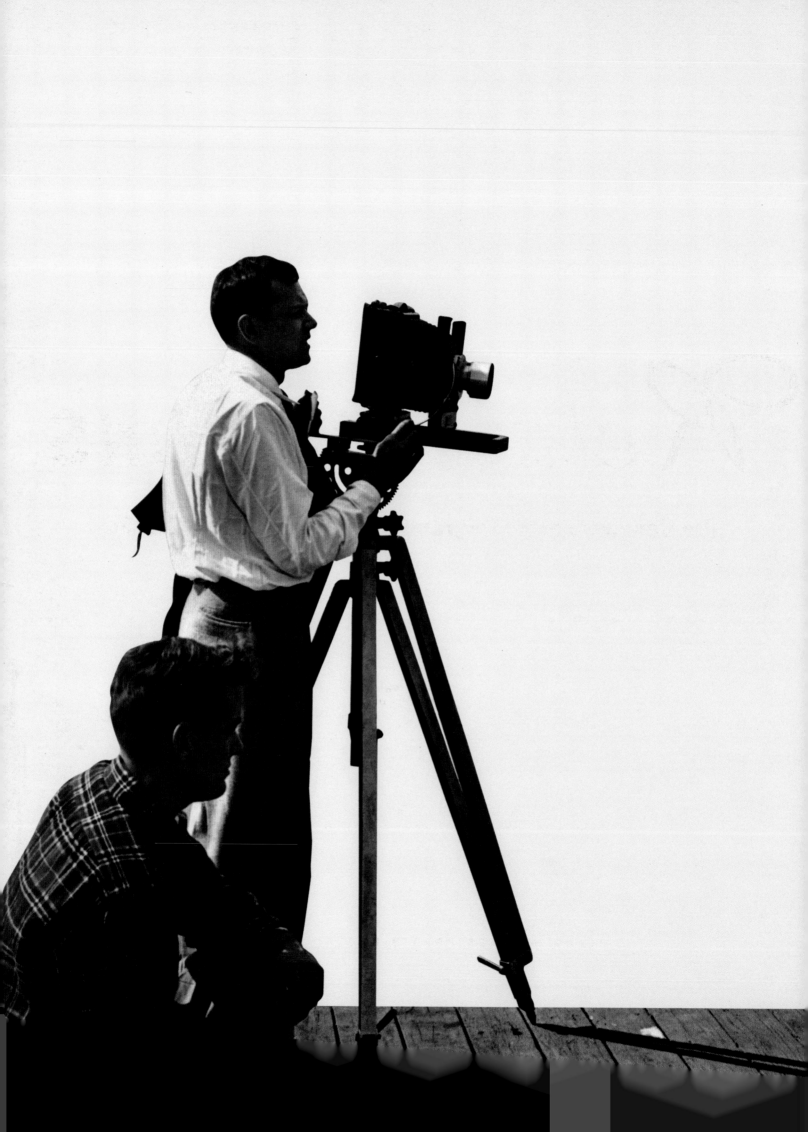

Retail FICTIONS

The Commercial Photography of Ralph Bartholomew Jr.

Tim B. Wride

LOS ANGELES COUNTY MUSEUM OF ART

Published by
Los Angeles County Museum of Art
5905 Wilshire Boulevard
Los Angeles, California 90036

Available through
D.A.P./Distributed Art Publishers
155 Sixth Avenue, 2nd Floor
New York, New York 10013-1507
Tel: (212) 627-1999
Fax: (212) 627-9484

Library of Congress Catalog Card
Number: 97-76008

ISBN: 0-87587-183-6

Editor: Chris Keledjian
Designer: Scott Taylor
Photographer: Steve Oliver

Printed in Hong Kong through
Global Interprint.

This book was published in
conjunction with the exhibition
*Retail Fictions: The Commercial
Photography of Ralph Bartholomew Jr.*,
organized by the Los Angeles
County Museum of Art and held
there from March 26 through
June 15, 1998.

Photo Credits
All photographs are reproduced
courtesy of the Bartholomew Family.
Additional acknowledgment is necessary
for the following works: page 6,
Los Angeles County Museum of Art,
Audrey and Sydney Irmas Collection;
page 13, courtesy Keith de Lellis; plate 67,
courtesy George Eastman House.

Front Cover
Photograph for an Eastman Kodak advertisement,
1954 (plate 99)

Frontispiece
Ralph Bartholomew Jr. and an assistant on location,
c. 1950

Back Cover
Photograph for a DuPont advertisement, 1943
(plate 20)

CONTENTS

FOREWORD

WHETHER CATEGORIZED AS fine art, documentary, or commercial, photographs are a constant in the visual experience of contemporary life. So pervasive are commercial photographs that they are rarely afforded more than cursory recognition. With the benefit of historical and contextual perspectives, a fuller understanding of their significance is possible.

Retail Fictions: The Commercial Photography of Ralph Bartholomew Jr. examines the work of a single photographer who expanded the vocabulary of commercial image-making while setting new standards for technology and innovation. Tim B. Wride, assistant curator of photography and organizer of this exhibition, demonstrates how Bartholomew masterfully manipulated emerging technologies, issues of identity, and references to popular culture to create visually arresting photographs. He also argues that Bartholomew's work— done for prestigious agencies and exponentially reproduced through the gargantuan circulation of popular magazines—exercised enormous influence and occasioned considerable imitation.

On behalf of the museum's trustees and the executive staff I would like to thank those individuals whose dedication and commitment brought this project to completion. Special acknowledgment and gratitude are also due to the Bartholomew Family for their magnanimous gift of a substantial body of the photographer's work.

GRAHAM W. J. BEAL

Director
Los Angeles County Museum of Art

Self-Portrait, 1940s

7

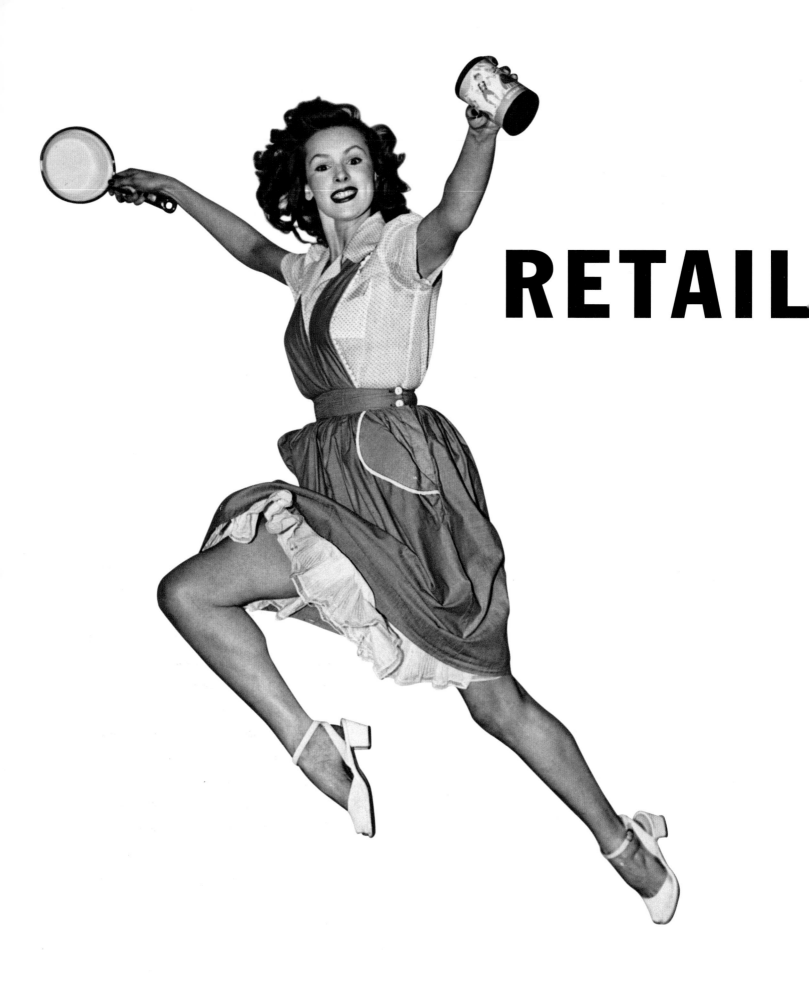

RETAIL

Keetman and Sons, 1939

Tim B. Wride

FICTIONS

The Commercial Photography of Ralph Bartholomew Jr.

I show them this can of Campbell's tomato soup.

I say, "This is soup."

Then I show 'em a picture of Andy Warhol's

painting of a can of Campbell's tomato soup.

I say, "This is Art."

"This is soup." "And this is Art."

Then I shuffle the two behind my back.

"Now what is this?"

"No, this is soup, and this is art!"[1]

JANE WAGNER
The Search for Signs of Intelligent Life in the Universe

COMMERCE OR ART? Until the relatively recent loosening of intellectual and conceptual strictures, it was generally believed that these two realms were mutually exclusive. The common perception was that an artist's participation in one would preclude his or her acceptance within the other. Photographers, who were still battling to establish their medium's credibility as a fine art, most especially were hobbled by this assumption. Alfred Stieglitz—entrepreneur, arbiter of public taste, and pioneer proponent and practitioner of photography as art—held firmly to the modernist notion of the noble, heroic, and singular mission of the artist, a mission not tainted by commerce. Stieglitz would "always find despicable those who would turn their talent to gold."[2] Inherent in this pure vision of the role of the artist is the assumption that should an artist answer to the "wrong" motivations and produce in the commercial field, there was no turning back to "art." This was a one-way street and the opportunities for "redemption" were few.

As the field of advertising illustration became increasingly specialized and defined during the 1930s, 40s, and 50s, the chasm between art and commerce widened. Mere facility with a camera was not sufficient to ensure that the art photographer's images would translate to a popular print format. Commercial photographers and art

directors had developed a distinct visual vocabulary with set conventions that were driven as much by market research as by creativity.

Ralph Bartholomew Jr. made no pretense to creating "art." He was a commercial photographer, and most of the work he produced was meant to be seen in a popular-magazine format. His images were intended to sell a product—whether political or editorial, a car or a camera, cleanser or candy, overcoats or underwear. Bartholomew contributed to the formation of advertising strategies from a privileged perspective: as most Americans, he was a consumer who readily absorbed advertisements and their images; he was a photographer who understood the potential impact of the images he made; most unusually, however, he had been an art director for a commercial advertising agency and had shepherded ad campaigns from conception to public presentation. His triple frame of reference as consumer, photographer, and art director enabled Bartholomew to make images that could allure, entice, communicate to, and coerce his target audience.

While some commercial photographers specialized in iconic product shots, Bartholomew was most widely recognized for his photographs of people and activity. His strength lay in his ability to capture people in manufactured situations that would economically describe or slyly imply broader narratives. With each assignment Bartholomew, through his staging, lighting, selection of models, mastery of process, and creativity, was ever the consummate storyteller.

Bartholomew established himself in New York in the mid-1930s and over the next twenty years became recognized as one of the industry's leading advertising and editorial photographers. He worked with every major advertising agency of his time, including Batten, Barton, Durstine and Osborn; J. Walter Thompson; and Foote, Cone, and Belding.[3] His client list, which reads like a *Who's Who* of corporate America, included Eastman Kodak, Texaco, and General Electric. His commercial images and editorial work appeared in the pages of such major magazines of the period as *Harper's Bazaar, Ladies' Home Journal, McCall's*, and *Redbook*. Bartholomew worked within a well-established tradition of advertising imagery[4] and produced a body of remarkable photographs that affected his audience, his target markets, and still affect us today— though assuredly in a different manner and for widely different reasons. Approximately fifty years after their making, Bartholomew's photographs must be viewed through an aggregation of histories, emotions, and experiences. Writer and film theorist Allen Weiss asserts that "a photograph is caught in the intersection of two sets of codes: those of artistic composition and production, and those of spectatorial aesthetic consumption, ruled by the systems of distribution and presentation. Only at the very instant of exposure can the photograph be deemed simply a pure trace; as a completed presented work it is highly coded, and its meanings overdetermined by the multiple significative and social systems into which it is inserted or implicated."[5]

Photographs have a multilayered patina of nostalgia, cultural history, and pictorial tradition, among other cultural and social codings, that causes us to read and react to them in a manner that supersedes their original context and intent. Additionally these codings are dynamic in nature, constantly interacting and redefining one another as new layers of association are applied. Looking at Bartholomew's work, it is especially important to recognize that all images, pictures, and photographs act upon one another—both forward and backward through time. All the images we have seen in the past form a structure within which we see and understand the images of today. By the same token, the images we absorb today and those that we will absorb tomorrow will influence our recollection of and emotional response to images we have previously seen. Photographs used in advertising become a part of our visual vocabulary and contribute to a frame of reference through which we see all images. In her book *Decoding Advertisements*, Judith Williamson observes that "advertisements are selling us something else besides consumer goods: in providing us with a structure in which we and those goods are interchangeable, they are selling us ourselves."[6] Williamson expands our understanding of the function of the visual frame of reference provided by advertising illustration to include the formation of social, cultural, and personal identities. By this process, Ralph Bartholomew's advertising photographs are compelling to us as documents, histories, and, most important, as collective memories. They provide us with the means whereby we can not only construct identities for products but are forced to recognize identities as products.

O N MAY 20, 1932, Ralph Bartholomew Jr. was awarded a certificate by the Clarence H. White School of Photography, signifying that he had "satisfactorily completed the professional course in photography." The school had been started by White in 1914 following his splintering off from Stieglitz's Photo-Secession. Two years later White would be instrumental in the formation of a new organization, the Pictorial Photographers of America, which would champion the pictorialist cause and aesthetic long after Stieglitz's interests would be drawn toward modernism and "straight" photography.[7] By the time Bartholomew arrived at the school, White had died and the school was being administered by his widow and youngest son.[8] Still, the school continued to advance its founder's visual philosophy and could count among its alumni such influential photographers as Margaret Bourke-White, Anton Bruehl, Laura Gilpin, Paul Outerbridge Jr., Ralph Steiner, and Doris Ulmann.

Students at the White School were given a rigorous, practical, aesthetic, and theoretical photographic education. As spelled out in its promotional literature, the school was founded as "a professional institution for the training of men and women for the vocation of photography. It treats photography not only as a fine art with an established technique, but also as a practical art, indispensable to modern commerce and

industry."[9] In this attempt to reconcile the realms of art, industry, and commerce, the White School anticipated some of the concerns of the German Bauhaus.[10] The curriculum was designed to foster a broad and expansive use of the medium—including its use in advertising and the graphic arts. In keeping with the senior White's aesthetic legacy, however, there was still a great reliance on the pictorialist traditions that had defined and sustained his work. Students and faculty alike were encouraged in all avenues of photographic expression. Among the instructors employed by the school during Bartholomew's time there were Charles J. Martin, who taught art appreciation and design, John Heins, also a design teacher, and Robert Waida, who taught studio practice.[11]

Bartholomew brought with him to the White School a varied background and, it would seem, a clear sense of the course he intended his photographic work to take. The eldest of three sons, Ralph Bartholomew Jr. was born on January 26, 1907, into a comfortable upper-middle-class household in Brooklyn, New York. His parents Ralph I. Bartholomew and Myra Kelley Bartholomew had also been born and raised in Brooklyn. His mother was a first-generation daughter of a wealthy railroad contractor. Ralph Sr. earned a law degree from Brooklyn School of Law, though he never practiced, and opted instead to enter the business world. Ultimately he became the director of marketing and advertising for Publishers Printing Company and the William Bradford Press and developed an amateur's interest in photography.[12] The senior Bartholomew's career and hobby would serve his eldest son well in later years.

Ralph Jr.'s own interest in photography began

at the age of nine when he was given a Premo Box Camera. Unfortunately his enthusiasm became a victim of bankruptcy almost overnight. With film costing 12¢ a roll, [he] found that just a few minutes of shutter clicking had dissolved not only his weekly allowance, but his savings as well.... Enjoying greater solvency in his teens, Ralph's interest in photography was rekindled as a hobby.[13]

Ralph Jr. attended prep school in Brooklyn where he ran track and cross-country. The summer following his graduation, he adventurously hired on to a steamer and worked his passage to Europe. Upon his return he attended Columbia University until his sophomore year when he suffered a nearly fatal case of pneumonia.[14] Bartholomew did not return to Columbia following his recuperation. Instead he began a two-year course of study at the Art Students League in New York. While at the League (1927–29), he continued his interest in photography but concentrated primarily on drawing and painting classes. During this period he was also developing an expertise in landscape architecture.[15]

In 1930 Bartholomew began his multidimensional career in commercial advertising and joined the prestigious firm of Batten, Barton, Durstine and Osborn (BBDO) as an assistant art director. BBDO had formed as the result of the merger of a young and energetic agency headed by Bruce Barton, Roy Durstine, and Alex Osborn with the older and more established firm of George Batten Company in 1928.

With combined annual billings of $32 million, the newly formed agency immediately ranked as one of the three largest American agencies, serving clients that included General Electric and General Motors.[16] Quickly distinguishing himself, Bartholomew was named to an art director position and began designing campaigns and supervising the photographers hired to produce illustrations for them. During his two years with the firm, he became increasingly interested in the illustration aspect of the business. His experience at BBDO ultimately fueled his desire to pursue a career as a professional photographer and precipitated his enrollment in the Clarence H. White School.

When Bartholomew started his freelance photography career in 1932, he inserted himself into a competitive, mercurial, and embryonic visual industry whose parameters were being redefined with each new campaign. Photographic illustration was dominated by the iconic and modernist approach (with an emphasis on the product) taken by such photographers as John Collins, Gordon Coster, Paul Outerbridge Jr., and Edward Steichen on the one hand and on the other by the more dramatic narrative and testimonial images being produced by Grancel Fitz, Lejaren à Hiller, and Victor Keppler. Within a five-year period following the completion of his studies at the White School, Bartholomew was able to build a clientele that included the National Biscuit Company (later known as Nabisco), Whitman Candies, and Steinway and Sons.

A photograph advertising Nabisco's Ritz Cracker reflects Bartholomew's own style of iconic modernism. Instead of carefully composing and lighting the product itself, an approach for which both Steichen and Outerbridge were known, Bartholomew chose to depict the packaged product situated within the machinery of its making. Besides being emblematic of the Machine Age during which it was produced, the image represents a shift in emphasis from the actual product to its packaging and brand name, a strategy meant to impel consumers toward the product as it would appear on retail shelves.

Nabisco, 1937

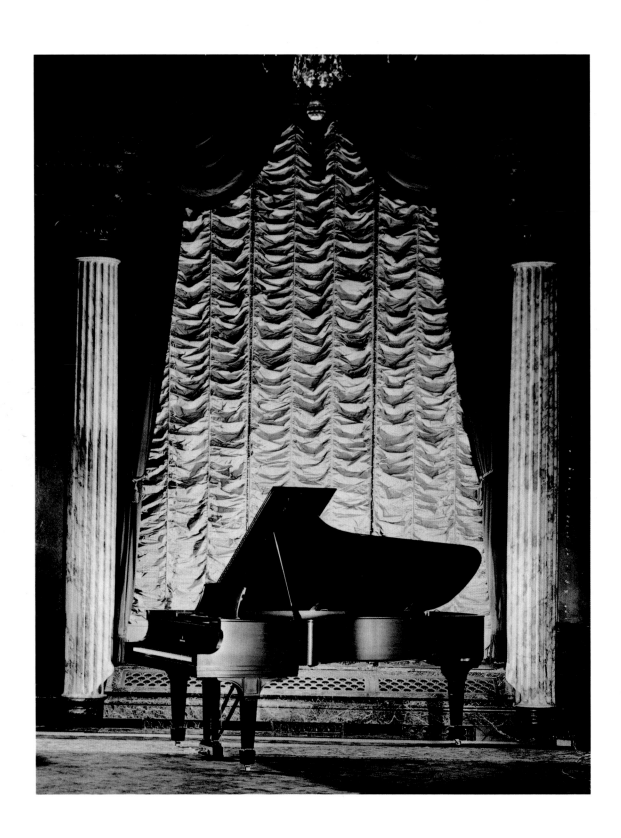

He also employed packaging as the centerpiece for narrative images, as in a sweetly romantic ad for Whitman Candies (plate 2). While this image does not exhibit the dramatic—often melodramatic—flair that is notable in the work of Keppler or Hiller, it is consistent with their work in its masterful orchestration of visual elements to support a narrative. The details—the cropped automobile, foliage, casually arrayed maps, corner of a closed picnic basket, rumpled blanket, and a woman's lit cigarette—create an idyllic scene built around the opened box of chocolates in the foreground.

Bartholomew coupled iconic product photographs with narrative images in a project undertaken for Steinway and Sons in 1935. His father, in a seeming reversal of initial apprehensions surrounding his son's choice to work independently, lent his support by contracting Ralph Jr. to produce a series of photographs for the piano maker's catalogue. The senior Bartholomew had authored a promotional pamphlet for the legendary piano maker that was printed by the William Bradford Press in 1929.[17]

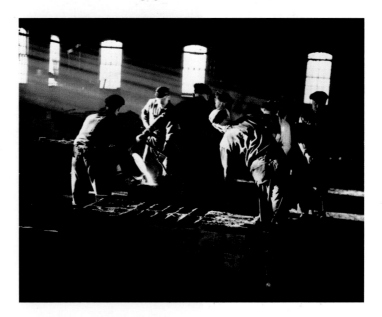

The earlier pamphlet included color wood-block illustrations[18] of the manufacturing processes at the Steinway factory. For the 1935 catalogue Ralph Jr. created product shots as well as a suite of manufacturing images. His photographs of the individual Steinway piano styles are sculptural and elegant but also very theatrical as a result of elaborate staging and lighting techniques. The photographs of the Steinway manufacturing processes, however— images of foundry workers casting sounding boards, carpenters preparing cases, and technicians assembling keyboards—closely paralleled the wood-block illustrations in the earlier pamphlet. The manufacturing images are rendered in a soft-focus style that not only reflects the pictorialist influence of the Clarence White School but also appears to be a paean to the dignity of the worker in the spirit of Lewis Hine's photographs of the 1930s. Responding to Steinway's desire to seamlessly merge the two aspects of their tried-and-true corporate identity, Bartholomew interspersed the narrative images, which served as an affirmation of old-world craftsmanship, with their iconic counterparts, which conveyed the elegance and prestige for which a piano by Steinway was a symbol.

In 1936 Bartholomew married Helen Kohler, a math teacher to whom he had been introduced by mutual friends.[19] The following year he was offered a job with Underwood and Underwood Illustration Studios. This must have pleased his father, who had returned to his earlier practice of frequently counseling his now-married son to forget about working for himself and become comfortably ensconced within the security of a corporate structure.[20] Underwood and Underwood Illustration Studios

was among the pioneering full-service agencies that supplied both graphic and photo-illustration for advertising and editorial clients at the time. Bartholomew began working in Underwood and Underwood's New York offices within the sphere of influence of Lejaren á Hiller, who had been with the firm since 1929 and at the time Bartholomew joined was well known for his meticulously staged, baroque, and often melodramatic illustrative style.[21] While Bartholomew was already using staging and lighting to great effect, as evidenced by the Steinway images, his affiliation with Hiller inspired a freer style and more flamboyant image-making options.

In 1937 Bartholomew became the chief photoillustrator in the agency's Detroit offices. With the same enthusiasm that Bartholomew had applied to the learning of his craft while an art director and then as a freelance commercial photographer, he doggedly applied himself to the creative solutions needed to satisfy some of Underwood and Underwood's top clients, among them the Ford Motor Company. As Bartholomew remembered, "Each new assignment somehow managed to raise a unique challenge peculiarly its own. You couldn't become bored — there wasn't time for it."[22]

Leaving Underwood and Underwood and returning to New York in 1938, Bartholomew began to reestablish himself as a freelance photographer, opening his own studio in Manhattan. Even after he moved his residence and began his family in Scarsdale in 1941, he continued to work out of his Manhattan studio for almost thirty-five years.

By 1939 he had built up a substantial body of agency work and an enviable client list that included General Electric, Continental Insurance, and the Texas Company (Texaco). His photographs were being used to illustrate articles in *Harper's Bazaar*, *McCall's*, *Redbook*, *Ladies' Home Journal*, *Good Housekeeping*, *Cosmopolitan*, and *Today's Woman*; and his fashion images were attracting such attention that by 1947 he was linked with Horst B. Horst, Erwin Blumenfeld, and Richard Avedon as a leading practitioner and innovator of the genre.[23] Even as Bartholomew was being recognized for the inventive nature of his photographs, he was also becoming known for his meticulous working methods and the studied effort he applied to every assignment.[24]

The images that Bartholomew achieved were casual in a way that belied the circumstances of their making: he relied on the bulky, unwieldy (but stable) view camera; he planned each shot methodically; and was meticulous in his attention to detail. In his working methods he balanced the creativity of a photographer with the practicality of an art director. In a 1952 essay he asserted,

In photography, if you have a purpose and an intent, you cannot allow yourself to be beset by gargantuan problems during the taking of pictures. These problems must be worked out in advance, and if you're not sure you've licked them before you start you stay away from them until you've mastered them by experiment before you attempt to make a picture. I do not mean that every minutiae should be rehearsed in advance, for if the taking became a purely mechanical routine, all spontaneity would be lost and the result could only be lifeless and dull.... Most of the stories of "tough" assignments, though they make good stories, don't seem to be conducive to good photography.[25]

The account of one of Bartholomew's own tough assignments, however, contradicts this last supposition. An advertisement for General Electric presented Bartholomew with a set of problems that not only made for a good story but also resulted in a most memorable picture:

The problem was to show a man and his wife who had just discovered their cellar flooded and their General Electric oil burner standing in 13 inches of water. During a tidal wave caused by a hurricane this actually happened. The story behind the picture was that the water eventually receded and the power was eventually restored to the GE burner which started up again automatically unharmed in any way. Although a drawing, because it would involve no technical problems, would have been the easier medium of illustration in this case, [art director] Leslie Beaton of Newell-Emmett...felt that if the job could be done photographically the ad would be more effective due to its greater realism.[26]

Bartholomew began devising a set that would faithfully yet safely re-create the flooded basement scene in his third-floor studio. First the G.E. oil burner was shipped in, and he ascertained that an eight-inch bottom support could be removed without sacrificing the appliance. This meant that the burner would only need to be set into five inches of water in order to simulate the flood. The remainder of the set was constructed to conform with the same reduction. Finally all the elements (burner, staircase, chair, and steamer trunk) were placed into a ten-by-twelve-foot tank filled with water. Bartholomew's planning had reduced the cost of the set as well as minimized the risks to his downstairs neighbors (and therefore his financial liability), since both the amount and the weight of the water were reduced by almost two-thirds.[27]

The resulting photograph (plate 104) is distinguished not only for the planning and work that was undertaken in the production of the set but for the wonderfully melodramatic reactions of the models on the stairway, heightened and amplified by the raking shadows cast upon the wall behind them, recalling the work of Bartholomew's former coworker Hiller. Keeping his client's priorities in mind, however, Bartholomew made the product the main focus of the image. In a remarkable contrast, the quality and reliability of the G.E. burner is emphasized as it stands undamaged amidst the other partially submerged, upended elements that define the scene.

Another hallmark of Bartholomew's advertising photography was his frequent use of nonprofessional models. He employed this strategy partly to appeal to a growing middle-class audience whose tastes and reading habits were reflected not in the *haute couture* fashion magazines dominated by photographs from Grancel Fitz and Nickolas Muray but in *Redbook*, *Ladies' Home Journal*, and *McCall's* as well as in the burgeoning ranks of juvenile publications such as *Junior* and *Senior Scholastic* and *Seventeen*, periodicals in which his images were frequently featured.

Bartholomew must have contributed enormously to the discretionary income of the Scarsdale area, as he would consistently feature friends, neighbors, and students and teachers from the local schools in his assignments. He must also have had a gift

for keeping his models focused yet at ease during the process of a shoot, for he was known to expose plate after plate, constantly requesting adjustments in pose and expression until he got the exact image he was after. His son later recalled one assignment that featured "a whole bunch of neighbors...around [a] truck. He must have taken sixty or seventy pictures.... Everything had to be just right [so] it went on and on and on. [My father was] a real perfectionist...very intense."[28]

Bartholomew's intensity and his eye for naturalness and detail also allowed him to recognize those circumstances when nonprofessional models with a particular expertise (as opposed to strictly professional models) were required to ensure the success of the image he was after. In 1940 Bartholomew worked again with Leslie Beaton on a series of photographs for a Texaco campaign, each of which was to be captioned:

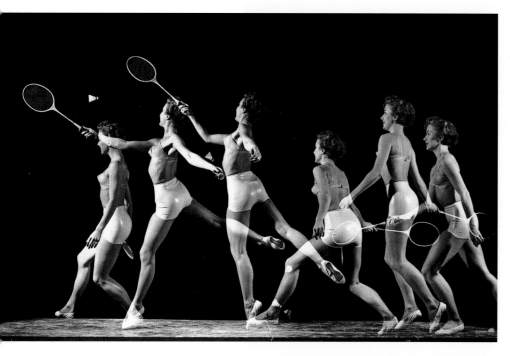

Playtex, 1950

"Out." Two professional baseball players and an umpire, complete with their uniforms and gear, were hired to make sure that an image showing one player sliding into home and being tagged "out" by the other was not only natural but technically correct. The umpire was subsequently photographed making the crucial call (plate 94). For yet another image in the series, Bartholomew employed a local tennis pro, though in this case not as a model. The professional functioned as a technical advisor to correct the stance and attitude of a female model in tennis attire and holding a racket in a situation where a tennis ball has seemingly been driven beyond the baseline and was therefore "out" (plate 95).

Bartholomew again encountered the dilemma of whether to use a professional model or an expert who could serve as a model in a series of photographs undertaken for the International Latex Company. The campaign, which was honored with the Best National Advertising Award for 1949 by the Art Directors Club, featured multiple stroboscopic exposures of women wearing only Playtex undergarments in a variety of athletic and dance sequences. Bartholomew knew that the graceful posture and movement of a ballet dancer would be necessary to assure the success of these photographs, so rather than search for models who could dance, he found dancers who had the poise and appearance of models.

It is difficult to imagine a time before Jockey, Haynes, and Calvin Klein ads, when the link between sex and apparel was not overtly made nor when it was not the

standard means by which "undergarments and foundations" were marketed. Not until the advent of the slogan "I dreamed I was [fill in the action word or phrase of your choice] in my Maidenform bra" in the 1950s was there an obvious shift in advertising sensibility towards fantasy and ultimately to sexuality in the marketing of women's, and later men's, underwear. Before this breakthrough campaign, however, images such as Bartholomew's photographs for Playtex were vainly trying to appear to be about anything but sex, while in reality being about little else.

The challenge Bartholomew faced in the Playtex campaigns was how to portray a woman wearing only a bra, girdle, garter, and stockings and not have the image's sexual overtones take primary importance. There was certainly no question that the ads would contain some sexual component. The key for the success of the campaign's message would depend on the photographer's ability to minimize that component. How could the images be "sanitized" for mass consumption so that the messages "Playtex = fun" and "these undergarments do not restrict motion" were not overridden by the blatant, though playful, sexuality of the photographs?

Certainly one factor working in Bartholomew's favor was that line illustrations of foundation-clad women had been commonplace in print advertising since the mid-1920s.[29] Therefore, the concept of featuring a woman attired only in her undergarments would in and

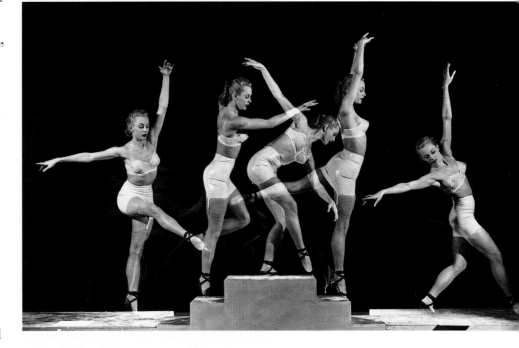

Playtex, c. 1950

of itself not be cause for alarm. More problematic, however, was how to mitigate the stark realism of a photographic illustration. One solution was to have the figures in the ads engaged in activities that were wholesome enough to lend an air of respectability to the images. Bartholomew chose such squeaky clean diversions as bowling, archery, and badminton—activities that were also being marketed to an increasingly leisure-oriented population at the time. One image even featured a "housewife," scantily clad in latex, wielding a stick to *simulate* the use of a mop or vacuum cleaner (plate 82). The model was thereby placed within the sanctity of hearth and home, equated with wife and motherhood, and therefore not available as a sexual object of desire. Dance, too, was enlisted in order to "clothe" the figure in "culture" and, it was hoped, once again render any sexual implications moot.[30] Finally, to further reduce the emphasis on sexuality, the art director and the photographer eschewed a static mannequinlike depiction in favor of a figure in motion. This visual and conceptual shift of emphasis

from static to kinetic was accomplished through Bartholomew's use of multiple-exposure, stroboscopic photography.

The equipment and techniques of modern stroboscopic photography had been pioneered by Harold "Doc" Edgerton in the labs at the Massachusetts Institute of Technology in 1931. Edgerton's research involved photographing moving subjects with high-intensity light flashes of very short duration. By 1937 he had reduced the duration time to 1/100,000 of a second, which made it possible to visually "freeze" nearly any movement. In addition, by exposing a carefully timed succession of "frozen moments" on one negative or transparency, the process could produce a sequential view of that movement.[31] Gjon Mili, who was an engineer with Westinghouse when he met Edgerton in 1937, became the first professional photographer to incorporate Edgerton's techniques in editorial work. His images of sports figures in action, celebrities, theater performances, and dancers often appeared in the pages of *Life* magazine. Mili's first assignment for *Life* in 1938 included a stop-action portrait of tennis champion Bobby Riggs in mid-serve.

Though Bartholomew was not the first photographer to use stroboscopic lighting, he did popularize the technique by employing it in print advertising. By the time the Playtex images were published, Bartholomew had been creating stop-action and multiple-exposure images for use in both editorial work and advertising for well over five years. His initial interest stemmed from a desire to bring a "spirit of rhythm" and a "zip" to his images and also because, as he put it, "while some people are afraid of snakes, others have phobias about high places—I'm scared of long exposures."[32] He designed and fabricated his own speedlight equipment initially, and his first chance to use it for an advertising campaign came when he was asked to make Keetman and Son's cleanser seem somehow exciting (plate 93). The resulting image of a woman leaping for joy, can of cleanser held aloft, displays a spontaneity not previously available to Bartholomew nor previously associated with a banal household product. He was increasingly called upon to produce similarly energized images for other clients; he found the short exposures perfect for conveying the drama and momentary anxiety of a falling woman for a 1943 DuPont carpet advertisement (plate 20) and the rhythm and exuberance of dancing teens for a Fresh deodorant ad in 1945 (plate 92).

Bartholomew's use of multiple-exposure, stroboscopic technology to record movement began as the result of a simple request from an art director for a photo-graph that could be taken "bing-bing-bing." Although he had never attempted images of this type before, Bartholomew assured the art director that he could do it—and spent the following two weeks working out the intricate electronic and practical challenges of the process. When finally satisfied that he was ready for the assignment, he contacted the art director only to be told that the client had decided to switch to another type of image for the advertisement. Nevertheless, Bartholomew continued

experimenting with the equipment and refined his technique.[33]

Bartholomew's multiple-exposure photography coordinates a pictorial rhythm with graphic economy and elegance, ensuring a balanced image that would be visually stimulating and still communicate the essentials of the product or idea. The

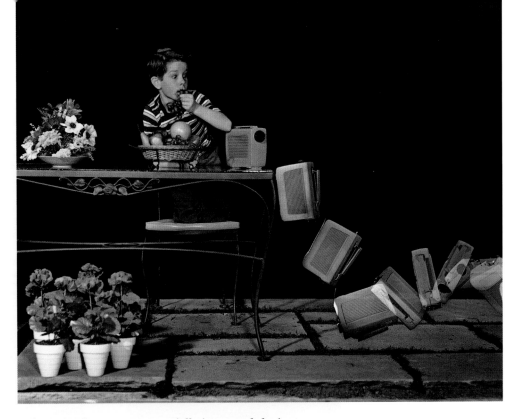

Unknown client, c. 1950s

problems inherent in taking any photograph were exponentially increased during multiple exposures. There were no formulas that could be followed, as each situation required individual determinations of lighting intensity, timing, and duration appropriate to such diverse subjects as dancing ballerinas in latex, a man sneezing (plate 96), a secretary at work (plate 18), a woman descending a staircase (plate 68), or a young boy knocking a radio from a table.

MARSHALL MCLUHAN noted in the mid-sixties that following the popular acceptance of movies within American culture "the entire pattern of American life went on the screen as a nonstop ad. Whatever any actor or actress wore or used or ate was such an ad as had never been dreamed of. The American bathroom, kitchen, and car, like everything else, got the *Arabian Nights* treatment. The result was that all ads in magazines and the press had to look like scenes from a movie."[34] McLuhan's contention that the cinema, as the dominant visual medium to a mass American audience, became the model after which all other visual media were patterned is well borne out in Bartholomew's photographs.

Bartholomew often used cinematic conventions as well as overt and pointed references to specific films or film genres in his advertising and editorial photography. A 1940 Texaco ad, suggestive of the romantic comedy in such films as *The Thin Man* (1934) and *My Man Godfrey* (1936), portrays a formally attired couple playfully tugging on the arm of a woman in a maid's uniform (plate 105). A shoot-out in a diner (plate 99), done for Kodak, recalls such film-noir thrillers as *This Gun For Hire* (1942) and *The Big Sleep* (1946). A Western showdown between gunslingers in front of a saloon (plate 12), another ad for Kodak, is reminiscent of *High Noon* (1952) or countless other classic "oaters." One of Bartholomew's most theatrical images, in which a terrified woman in a Victorian setting draws back in horror from a chandelier overhead

(plate 103), is a blatant reference to the film *Gaslight* (1944). The vertiginous angle from which she is seen and the deep shadows are meant to induce anxiety in the viewer. Bartholomew's use of chiaroscuro—deep shadows and a stark contrast between dark and light—is evident in many of his more theatrical photographs, including images done for General Electric, Texaco, and Playtex.

While Bartholomew was sometimes literal in his references to certain films, he was seldom direct in his references to specific movie characters in his photographs. One glaring exception, however, is an image from the 1940s featuring a female model offering a pillow to her obviously discomfited male counterpart (plate 106). Bartholomew purposely used Penny Singleton and Arthur Lake look-alikes to link the comfortable familiarity of the movie characters Blondie and Dagwood (based on the comic-strip characters created by Chic Young) to his client's product. Generally, however, Bartholomew featured less specific and more generic movie "types." This is apparent in his characterizations of a grandmother for a 1950 Ford campaign (plate 7) and a kindly family doctor featured in a 1951 Bosco (chocolate syrup) advertisement (plate 8). These advertising models conformed more with stereotypical film characters that would be instantly recognized and identified by the general public.

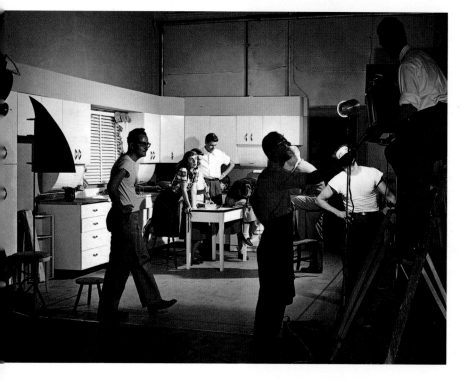

Bartholomew at work for Eastman Kodak, 1948

In this one might see a link to the pictorial strategies of contemporary artist Cindy Sherman, who made use of generic characterizations in her *Untitled Film Stills* series of the late 1970s and early 1980s. The most pervasive and far-reaching use of generic characterizations by Bartholomew, however, is found in the large body of photographs he produced for Eastman Kodak between 1946 and 1954.

In an employee newsletter dated March 24, 1947, the J. Walter Thompson Agency (JWT) announced that their longtime client Eastman Kodak had begun a new marketing strategy that would target the adolescent sector of the American market.[35] Founded in 1878, JWT was not only one of the oldest advertising firms in New York but also one of the largest. Through JWT, Kodak began employing surveys and market research, innovative at the time, to define the "habits and interests of young people who [would] be tomorrow's big users of cameras and film."[36] While this was not the first time Kodak had courted the youth market,[37] it would signal a shift in the direction of their products and marketing strategy. JWT, following this research, identified the strongest situational motivators providing the most direct appeal to this market: peer-group

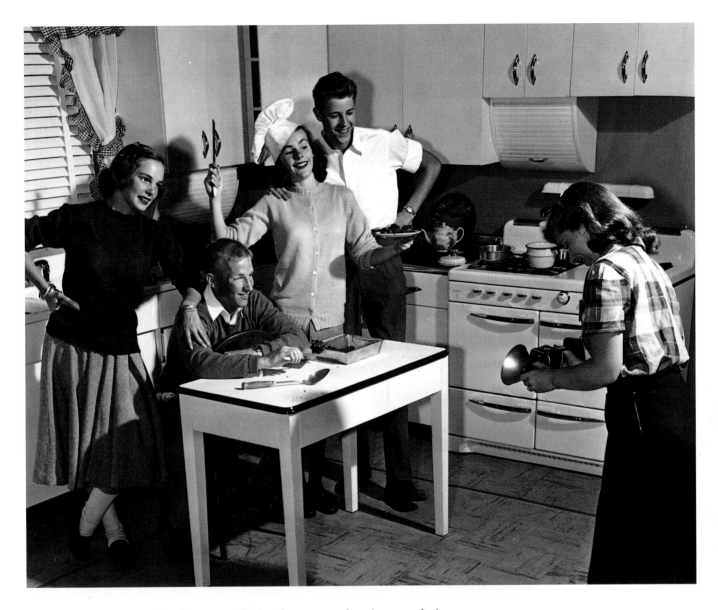

Eastman Kodak, 1948

acceptance and playful enjoyment. Their subsequent advertisement design strategy incorporated a "fun-and-popularity theme, which stresse[d] that everybody likes photographs—and implie[d] the corollary that everyone likes the picture taker." The advertising copy featured "youthful language" and the pictures would "show attractive youngsters in their accustomed haunts, with the photographer the center of interest."[38]

Their choice for an illustrator was "Ralph Bartholomew Jr., crack teen-age photographer." The announcement went on to explain that "Bartholomew was called in because of his outstanding camera work for *Seventeen*. Occasionally he plays records to get the models in the mood, and invariably comes up with pictures that reflect the teen-age atmosphere to perfection."[39]

Bartholomew's photographs for the Kodak campaign idealized American adolescence. Whether consciously or not, he employed cultural archetypes that had been established through such film characters of the 1930s and 40s as Henry Aldrich and Nancy Drew, who were themselves appropriated from the literature of the period. The models for the mythic American adolescent were fun-loving and industrious;

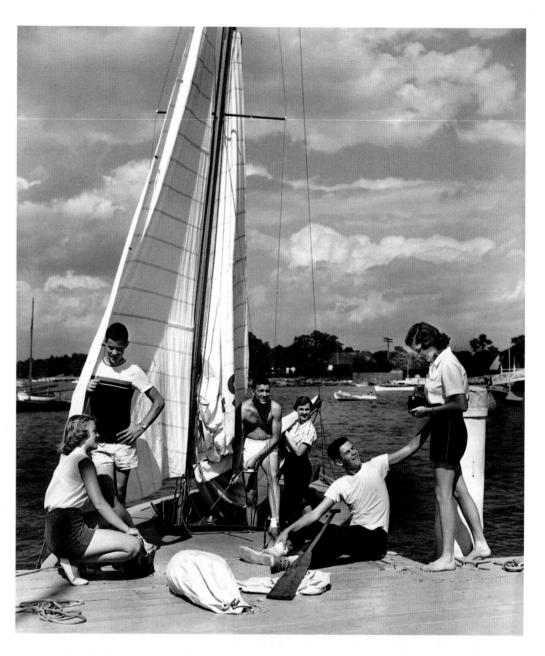

they obeyed, though often outsmarted, their elders; and they were active academically, athletically, and socially. They embodied the hopes of the future and were therefore the agents of stabilization for a social structure that had suffered the upheavals of the Depression and a World War.

Reflecting their literary prototypes, characters played by the adolescent Mickey Rooney and Judy Garland in such films as *Love Finds Andy Hardy* (1938) and *Babes in Arms* (1939) personified ideal teens. Shirley Temple in *The Bachelor and the Bobbysoxer* (1947), Jeanne Crain in the period piece *Cheaper by the Dozen* (1950), and even Elizabeth Taylor in *Father of the Bride* (1950) continued the stereotype of the American teenager from the previous generation. The hemlines were changed, and the language was different, but the sense of what an American teenager should be in relation to the family remained much the same and was merely spruced up for a new round of consumer identification.

Bartholomew's post-World War II photographs for Kodak campaigns aimed at adolescents reflected and reinforced the earlier prewar juvenile characterizations. Such exemplars were absorbed into postwar film and commercial uses and subsequently led to manifestations of the "typical" American adolescent on the now-classic 1950s and 60s television shows of family life: Betty, Bud, and Kathy Anderson of *Father Knows Best*, Mary and Jeff Stone of *The Donna Reed Show*, and David and Ricky Nelson of *The Ozzie and Harriet Show*.

Each Kodak ad of the campaign pictured either a teenaged boy or girl (depending upon whether the ad was to be featured in a magazine that catered to boys or girls) taking a photograph of his or her friends in a variety of "typical" teen activities.[40] The activities featured in the photographs were linked to the time of year that the ads were to appear. In winter teens in heavy sweaters, woolen caps, and gloves were shown skiing, ice skating, or even raiding the refrigerator. Spring situations revolved around school dances, plays, and graduation. Summer, of course, meant outdoor activities, including baseball, archery, sailing, or playing at the seashore. Autumn activities centered on school, with pep rallies, dormitory gatherings, Halloween parties, and hayrides. The use of Kodak cameras and film was subtly associated with fun and peer-group approval.

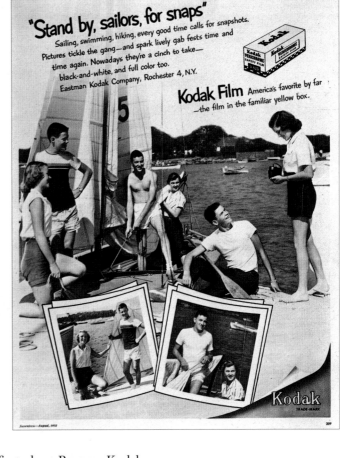

Illustrations that equated a product with an emotional state were not new to advertising photography nor to Bartholomew. It was in part his ability to achieve this result that had landed him the Kodak account in the first place. Because Kodak was the client, however, an innovative feature of the ads was that surrounding the central photograph were smaller snapshot images that the teen photographer was to have taken. The advertisement featured, therefore, not only the activity of taking photographs but also the photographs themselves. This layout strategy effectively merged the scene being photographed, the act of photographing the scene, and ultimately the resulting photographs into a single experience. In this way "fun" and "popularity" as demonstrated in the activities were first associated with the act of photographing and then with the photographs themselves. Subsequent Kodak campaigns would take the process one step further and make viewing the finished photographs part of the fun available through the use of Kodak products. The success of their adolescent marketing strategy would carry Kodak, J. Walter Thompson, and Ralph Bartholomew well into the mid-1950s.

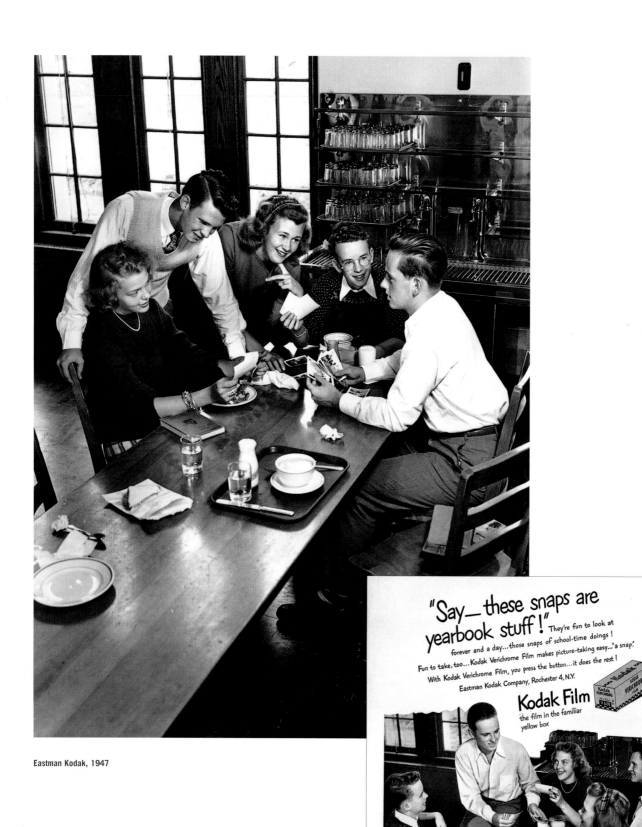

Eastman Kodak, 1947

By the late 1950s and early 1960s a radical shift in the advertising industry was underway. Television had begun challenging the print media as the prime arena for advertisers. Though dollars spent on print advertising were at an all-time high, there were signs of changes in the air. A new, more urban "look" was commanding attention, typified by the work of such photographers as Henry Wolf, Bert Stern, and Irving Penn. Additionally a spate of new commercial agencies and agency mergers were changing even the way business was being done.[41] Bartholomew did not fare well in this upheaval. It was as if the business and industry of advertising had moved on without him. He continued to produce interesting and arresting photographs for Kodak campaigns, but because the company's advertising strategies had shifted away from what was perceived to be his strong suit, the number of assignments he received from them dwindled.[42] The demand for multiple-exposure advertising photographs had run its course some years before,[43] and his workload dropped precipitously. Ever the innovator, Bartholomew investigated methods for the economical production of three-dimensional photographs and was granted two patents associated with the process in 1968. Although he was still producing photographs, he would never again command the level of commercial attention for his images that he had previously enjoyed.[44] Bartholomew continued to work out of his New York studio until retiring in 1972 and died quietly in his Scarsdale home on March 8, 1985.

RALPH BARTHOLOMEW JR. could have been indistinguishable from thousands of other photographers doing commercial work during the 1930s through the 1950s. Yet, he gained distinction because of the innovation and effectiveness of his photographs. That his work was appreciated in his own time is easily demonstrated by the number and caliber of agencies and corporate clients for whom he provided images. The bases for the popularity of his images and his style were his mastery and sensitive incorporation of new stroboscopic technology into a burgeoning commercial sphere; his use of cinematic situations and references; and his talent for visually tapping into and reinforcing the socioeconomic self-perceptions and yearnings of three generations of consumers.

Bartholomew created attainable fictions whose "realities" were based both in films and in a very narrow way of life found in the suburbs of the American northeast. These fictions, as well as those created by some of Bartholomew's more influential colleagues, became the accepted formulaic aspirations of an entire generation of consumers. By the time Bartholomew began making images, the cinematic exemplar had been translated to the pages of upscale magazines through the work of such photographers as Fitz, Hiller, and Keppler. One of Bartholomew's contributions was the extension of this narrative mode of identification to a middle-class audience. Bartholomew's narrative strategies anticipated the work of such photographers as

Richard Avedon (for Christian Dior, 1982), Rebecca Blake (for Bollinger Champagne, 1986), and Denis Piel (for Donna Karan, 1986).

While these factors may explain the power of Bartholomew's photographs at the time of their making, they do not adequately explain how his images still captivate us today. The continued impact of his photographs owes more to our understanding of the nature of commercial images than with their specific association with the products they were created to sell. Cultural critic Jean Baudrillard argues that advertising "in its entirety constitutes a useless and unnecessary universe." He maintains that the power advertising exerts results from its "disproportionate" use in society, which ultimately renders it not as an adjunct to consumption but as itself "an object to be consumed."[45] Baudrillard further asserts that the process of this consumption is a means of achieving the "regression of the individual into a social consensus."[46] This conflates neatly with Judith Williamson's contention that advertising sells consumers "an image of them-selves." When Bartholomew's images are viewed within this context of the formation of self-image and of social consensus, they can be read as contributing to a framework through which we view our past. The power of Bartholomew's images (and of all successful advertising images) is located in this conditioned reaction, the degree to which they are internalized by the viewer. Their *faux* realities are commingled with the actual experience of the viewer and are thereby assimilated. The images act as collective memory, as a shared recollection whose source is not the actual experience but the acceptance of the experience through the image. This experience, once-removed as it were, manifests as an aching sense of nostalgia. Since interpretations and judgments are formulated based upon previous experience, these emotional responses—as stand-ins for actual experience—become active agents for subsequent action. Bartholomew's fictional situations become regarded as truths and hereafter as histories. As they became enmeshed within the personal lore of their audiences, they were extended and unquestioningly reinforced by each successive generation. By this process, the photographs of Ralph Bartholomew Jr. have affected not merely products, or sales, or even advertising strategies but have influenced how succeeding generations have constructed their past, themselves, and their future.

1 Jane Wagner, *The Search for Signs of Intelligent Life in the Universe* (New York: Harper Perennial, 1990), 29.

2 Benita Eisler, *O'Keeffe and Stieglitz: An American Romance* (New York: Doubleday, 1991), 36. Given Stieglitz's philosophy, it is ironic that many members of his Photo-Secession would go on to provide images and instruction to a burgeoning commercial market. Clarence H. White would establish a school to train commercial photographers, and even Edward Steichen, who had cofounded the Little Galleries of the Photo-Secession (later named "291"), would provide seminal commercial images in the 1920s.

3 For a general history of advertising agencies and the personalities who drove them, see Stephen Fox, *The Mirror Makers: A History of American Advertising and Its Creators* (New York: William Morrow, 1984)

4 For a general history of advertising photography, see Robert Sobieszek, *The Art of Persuasion: A History of Advertising Photography* (New York: Harry N. Abrams, 1988).

5 Allen S. Weiss, *Perverse Desire and the Ambiguous Icon* (Albany: State University of New York Press, 1994), 129.

6 Judith Williamson, *Decoding Advertisements* (London: Marion Boyars Publishers, 1978), 13.

7 White served as first president of the Pictorial Photographers of America, whose other founding members included Karl Struss, Laura Gilpin, and Gertrude Käsebier.

8 White died suddenly while leading a photography class on an excursion to Mexico in 1925.

9 Cited in Susan Doniger, "The Clarence H. White School of Photography," *A Collective Vision: Clarence H. White and His Students*, ed. Lucinda Barnes (Long Beach: University Art Museum, California State University, 1985), 19.

10 This is not to imply any direct influence of the White School on the Bauhaus nor to compare the far-reaching effects of both schools but merely to illustrate the progressive curriculums of the two. For a general survey of Bauhaus photography, see Jeannine Fiedler, ed., *Photography at the Bauhaus* (Cambridge: MIT Press, 1990).

11 For a fuller analysis of the Clarence White School and its impact on photography, see Marianne Fulton, ed., *Pictorialism into Modernism: The Clarence White School of Photography* (New York: Rizzoli, 1996).

12 Family and anecdotal information concerning the life and working method of Ralph Bartholomew Jr. was taken from interviews done in 1996 with his widow, Helen, his sons, Ralph III and Edward, and his daughter-in-law, Margaret.

13 This anecdote was included in a profile of Bartholomew written for the Famous Photographers School, where he taught in the 1960s along with Richard Avedon and Bert Stern.

14 Interview with Ralph Bartholomew III, January 21, 1996.

15 Bartholomew would continue to sketch and paint (primarily nudes) for most of his life. His interest in landscape architecture would also continue throughout his lifetime and even became a somewhat professional endeavor. He is credited as the landscape architect for a New York house featured in *House Beautiful* (October 1932): 238–39.

16 Fox, *The Mirror Makers*, 106–7.

17 Ralph I. Bartholomew, "The Making of a Steinway," pamphlet, Steinway and Sons, 1929.

18 The wood-block illustrations were done by Winold Reiss (1886–1953), who was born in Germany and immigrated to the United States in 1913. He was a graphic and interior designer, an illustrator, and educator known primarily for his portraits of African-Americans in Harlem and American Indians. See Jeffrey C. Stewart, *To Color America: Portraits by Winold Reiss*, exh. cat. (Washington, D.C.: Smithsonian Institution Press for the National Portrait Gallery, 1989).

19 Helen had completed her undergraduate work at Adelphi College and subsequently would receive a master's degree in psychology from Columbia University in 1949. In 1938 Ralph and Helen established a residence in Riverdale, New York, and moved in 1941 to Scarsdale, where their sons were born: Ralph III in 1941 and Edward Kelley in 1943.

20 Interview with Ralph Bartholomew III, January 21, 1996.

21 Hiller is credited with having produced the first photographs to be used to illustrate a story in a magazine (*Cosmopolitan*). His most often referenced and certainly most notorious series was *Surgery through the Ages*, done over a twenty-year period beginning in 1927 for Davis and Geck Pharmaceuticals. See Sobieszek, *The Art of Persuasion*, 66, 194.

22 "Meet Your Instructor...Ralph Bartholomew," pamphlet, Famous Photographers School, n.d.

23 Dr. Mehemed Fehmy Agha, "Fashion Photography Today," *Photography* (fall 1947). Dr. Agha served as art director for Condé Nast Publications from 1929 to 1943.

24 "How These Pictures Were Made," *U.S. Camera* (July 1953).

25 Ralph Bartholomew, "The Human Figure in Motion." This manuscript remains unpublished; however, a related text can be found in George Barris, *Candid Photography with High-Speed Flash* (Greenwich, Connecticut: Fawcett Publications, 1952).

26 "Flood," *Photo Technique* (November 1940): 8–9.

27 Ibid.

28 Interview with Ralph Bartholomew III, January 21, 1996.

29 Charles Goodrum and Helen Dalrymple, *Advertising in America: The First 200 Years* (New York: Harry N. Abrams, 1990), 204. It should also be noted that the use of female nudity in advertisements while not commonplace was at least in use by the time Bartholomew had undertaken the Playtex campaign. An Edward Steichen image that appeared in a 1936 Woodbury's Facial Soap ad is credited as the first photograph of a female nude in advertising. See ibid., 73.

30 Ironically, the appearance of a "masked" ballerina in one of the Playtex ads (plate 73) effectively negates any attempt on the part of either the advertiser or the photographer to mitigate the sexuality of the ads. The dancer is now wearing a sign of fantasy and masquerade. The appropriation of Apollonian culture as a cloaking device has been replaced by the more blatant depiction of Dionysian revelry. The mask, in this case, unmasks and reasserts the erotic content of the image.

31 Edgerton's technique of multiple-exposure stroboscopic images should not be confused with the technique employed by Eadweard Muybridge in his landmark nineteenth-century compilation *Animal Locomotion*. Muybridge's images were the result of advancements in camera technology while Edgerton's were the result of advancements in lighting technology.

32 Ralph Bartholomew Jr., "Not Just Because It's Fast…," *Commercial Camera Magazine* (October/November 1947): 3.

33 "How These Pictures Were Made," *U.S. Camera* (July 1953).

34 Marshall McLuhan, *Understanding Media: The Extensions of Man* (New York: McGraw-Hill, 1964), 231.

35 "JWT Campaign of the Week: Eastman Kodak Company," *The JWT News* (March 24, 1947): 3.

36 Ibid.

37 For a discussion of Kodak's early attempts at market definition and access, see Dan Meinwald, "Picture Perfect: The Selling of the Kodak Image," *Frame/Work* 1, no. 2 (1987): 15–25.

38 "JWT Campaign of the Week," *The JWT News* (March 24, 1947): 3.

39 Ibid.

40 The activities were "typical" only in so far as they presented a suburban New England range of activities.

41 See Fox, *The Mirror Makers*, 175–217.

42 The demise of Bartholomew's contribution to the adolescent campaigns of Kodak may be seen as a result of the success of his images. For almost a decade the Kodak images produced by Bartholomew set the tone for situations in which Kodak products played a major role. Given that the target market for these advertisements was the adolescent population, this means that at the end of the campaign, the target market had grown into adulthood with cameras in tow. They now became proselytizers for the products they so fully embraced as a result of Bartholomew's pictorial indoctrination. Their children would be the most imaged generation of the twentieth century. The camera would play a significant role in their everyday lives and how they recorded and remembered them. They were and are being photographed from cradle to grave. Kodak's adolescent campaign thereby set up a self-perpetuating growth market for their products. (Kodak has perennially been the imaging industry leader. Unfortunately for Kodak, the campaign's success also defined the potential of the amateur market for competitors, as well. Contemporary advances in new imaging techniques has seen the use of the still-image analog cameras increasingly supplanted by digital and video technologies. Both of these factors have threatened Kodak's long-held supremacy in the amateur imaging sector.)

43 Bartholomew produced his final series of Playtex multiple-exposure photographs in 1954.

44 Bartholomew was accorded a different kind of recognition the month before his death when his photographs were exhibited at the Daniel Wolf Gallery in New York. The exhibition was titled *Ralph Bartholomew: The Great American Snapshot* and was on view from February 5 through March 2, 1985.

45 Jean Baudrillard, *The System of Objects*, trans. James Benedict (London: Verso, 1996), 164.

46 Ibid., 173.

PLATES

PLATE 1 Eastman Kodak, 1948

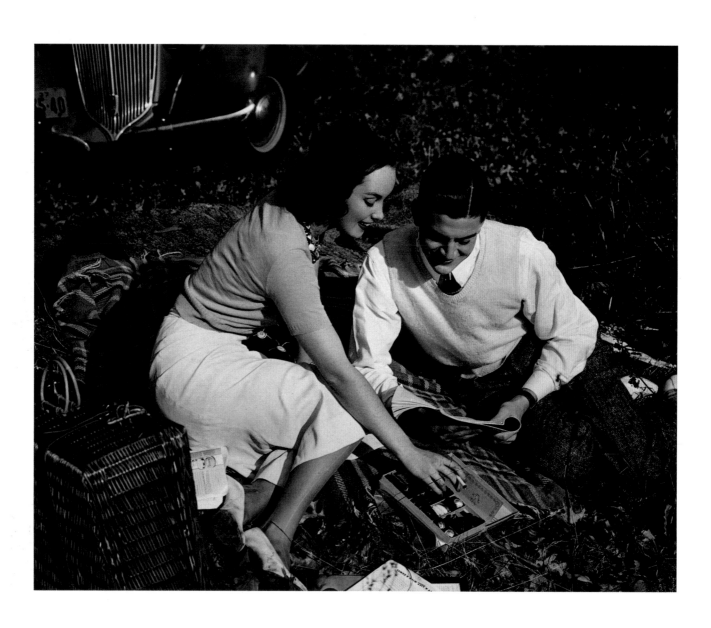

PLATE 2 Whitman Candies, 1937

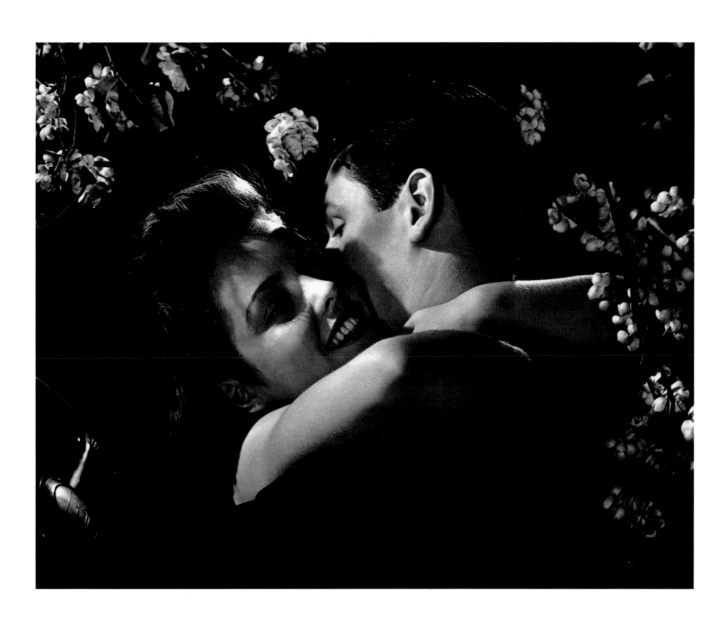

PLATE 3 Unknown client, c. 1940

PLATE 4 Pepsi-Cola, 1950

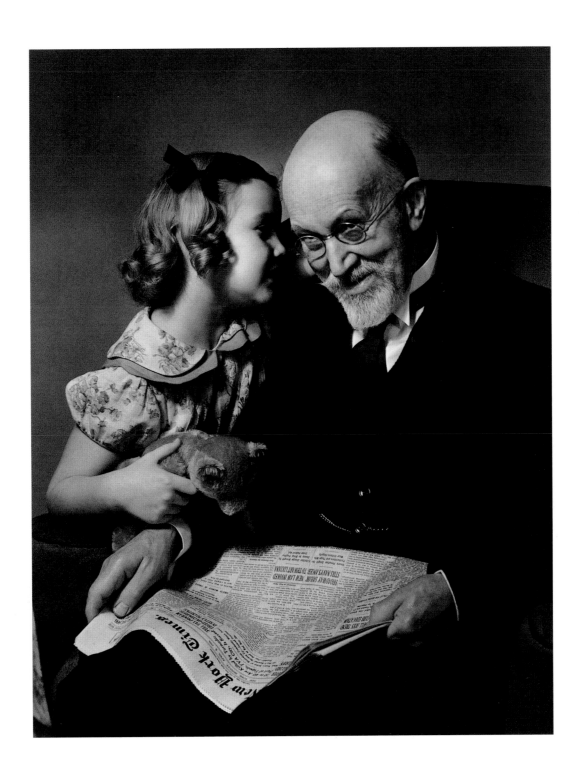

PLATE 5 Unknown client, 1936

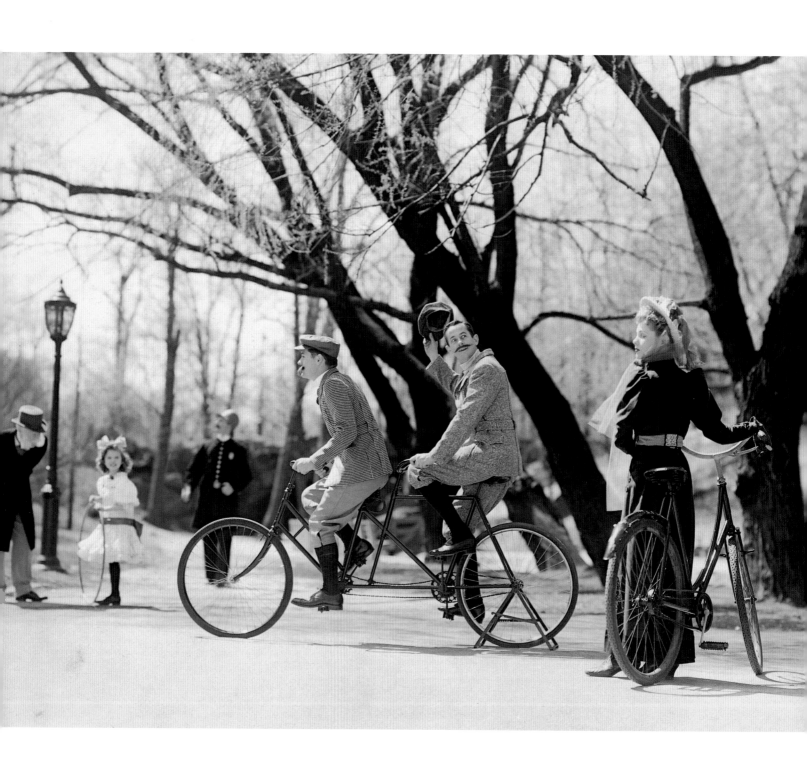

PLATE 6 Eastman Kodak, 1954

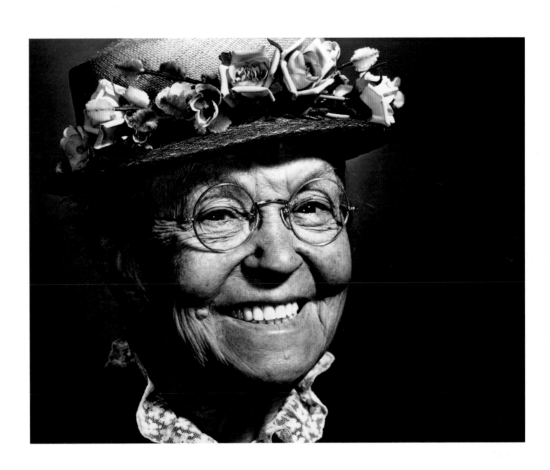

PLATE 7 Ford Motor Company, 1950

PLATE 8 Bosco, 1951

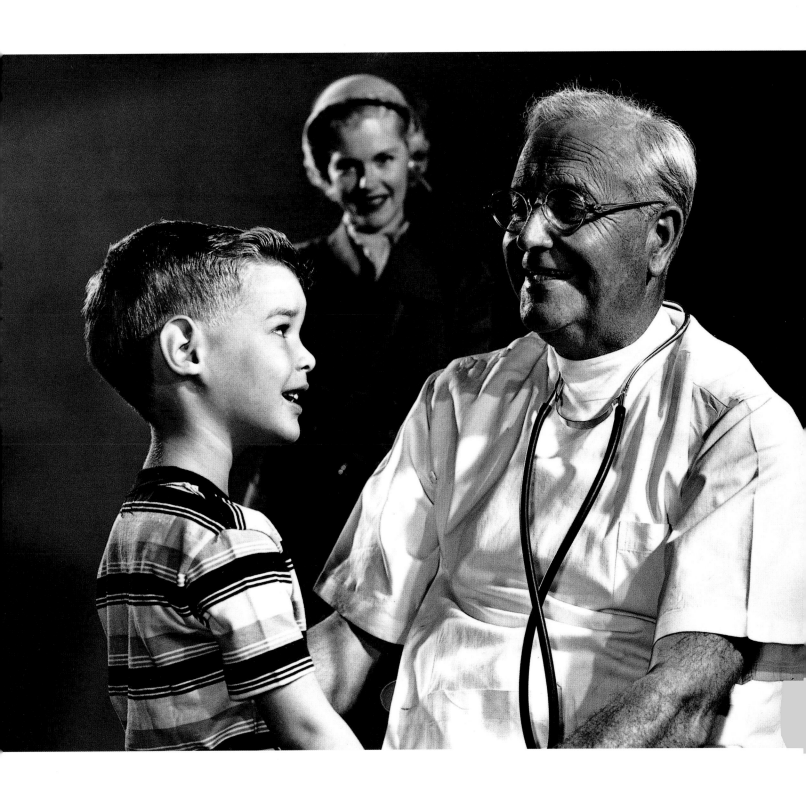

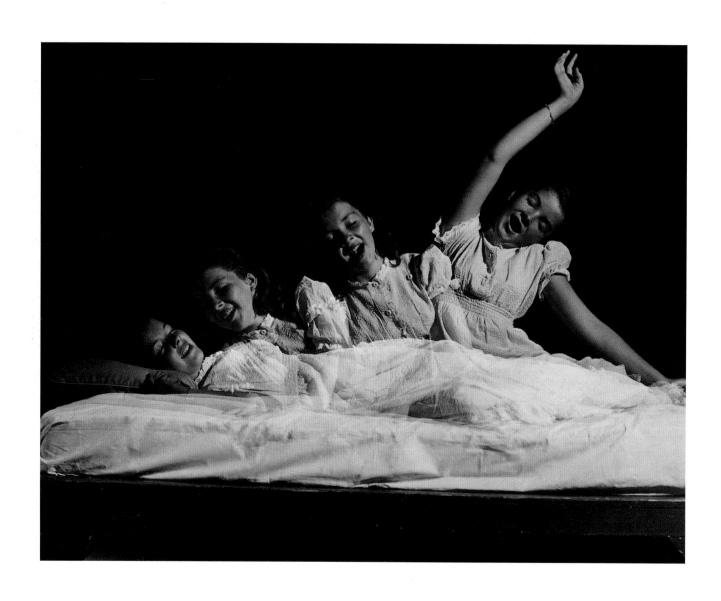

PLATES 9–10 Playtex, 1950

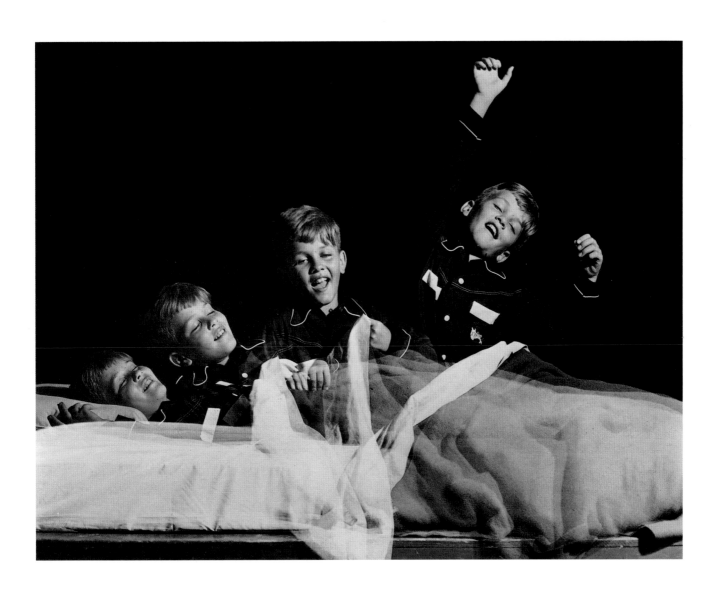

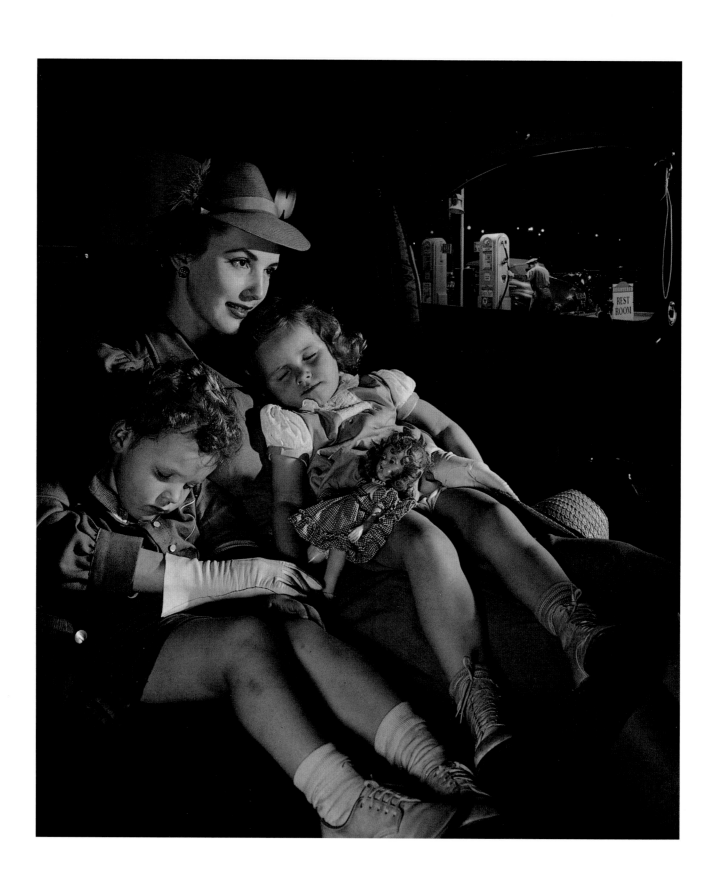

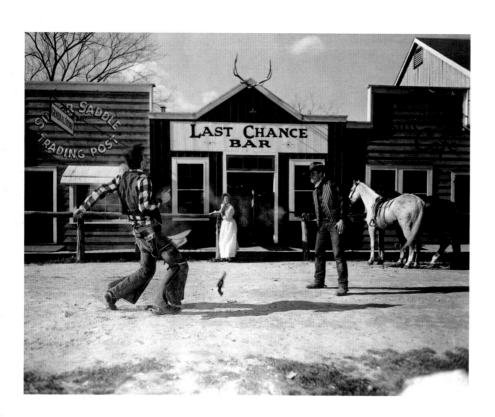

PLATE 12 Eastman Kodak, 1953

PLATE 13 Electric Light and Power Companies of America, 1952

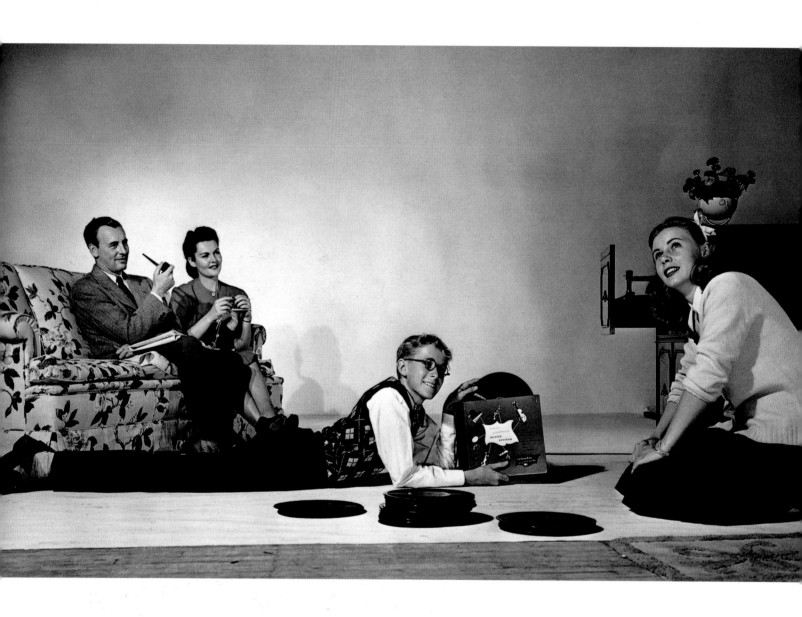

PLATE 14 Columbia Records, 1946

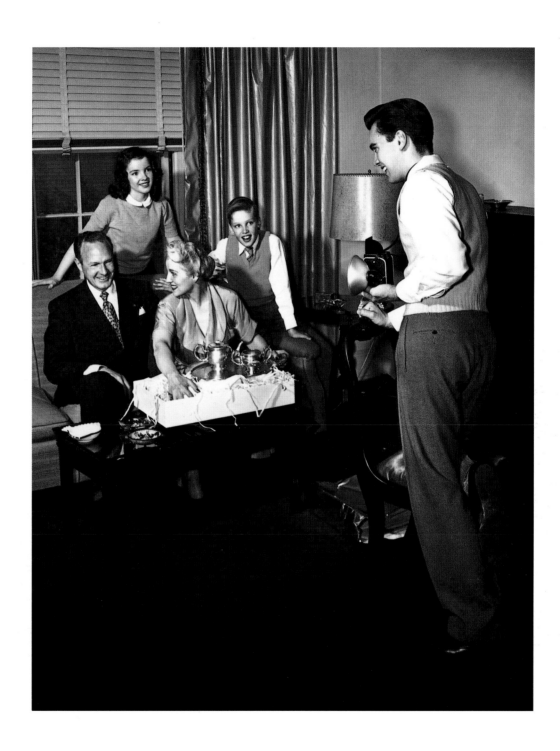

PLATE 15 Eastman Kodak, 1950

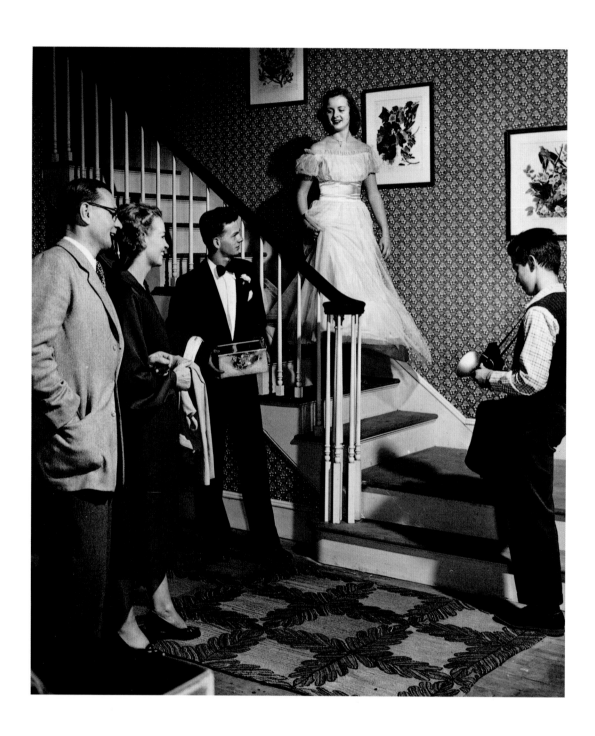

PLATE 16 Eastman Kodak, 1950

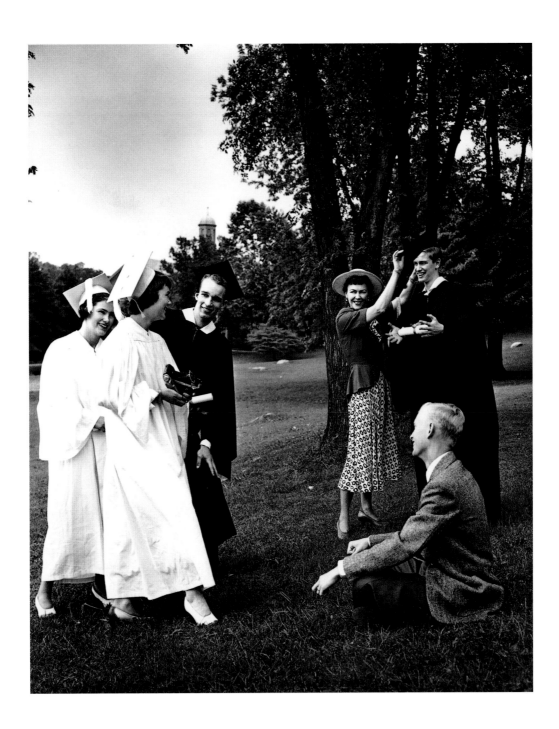

PLATE 17 Eastman Kodak, 1950

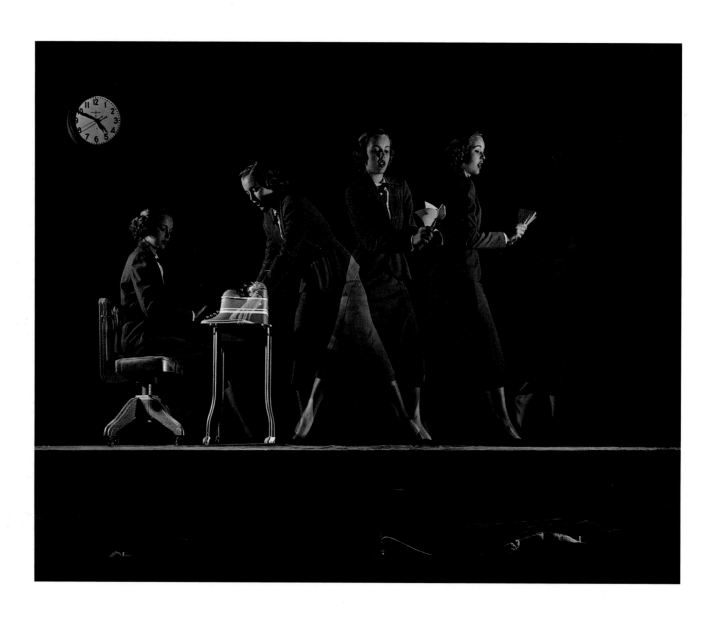

PLATE 18 *Cosmopolitan* Magazine, 1948

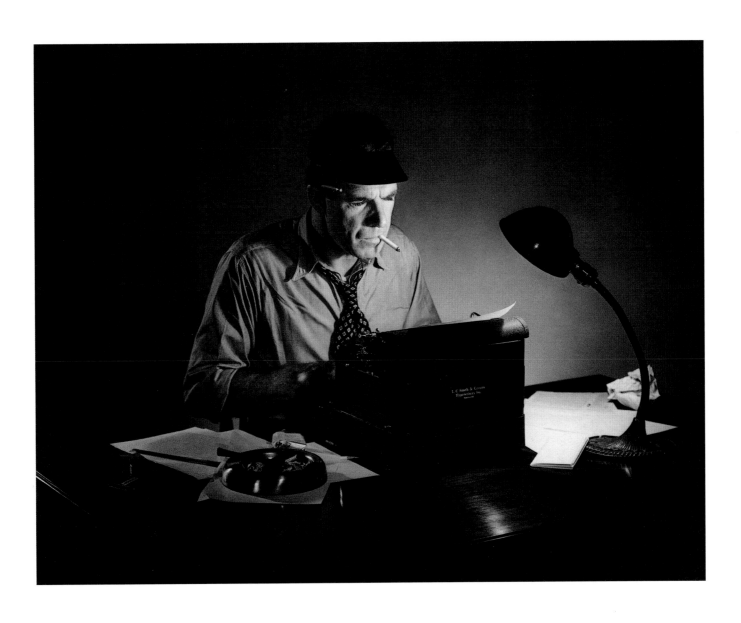

PLATE 19 Unknown client, c. 1945

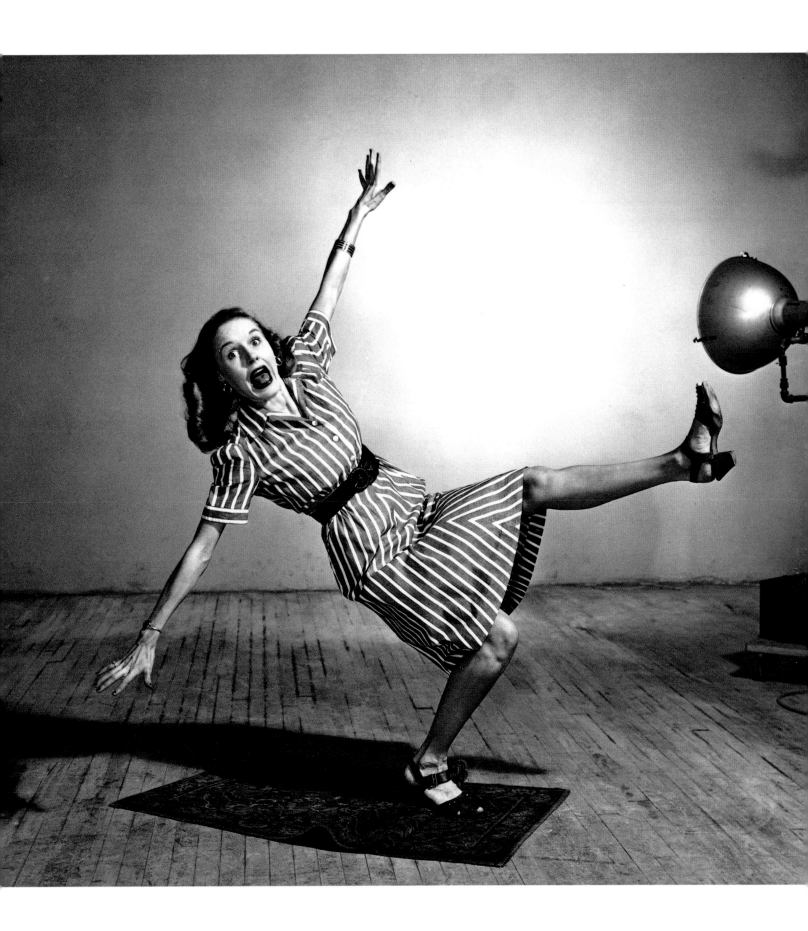

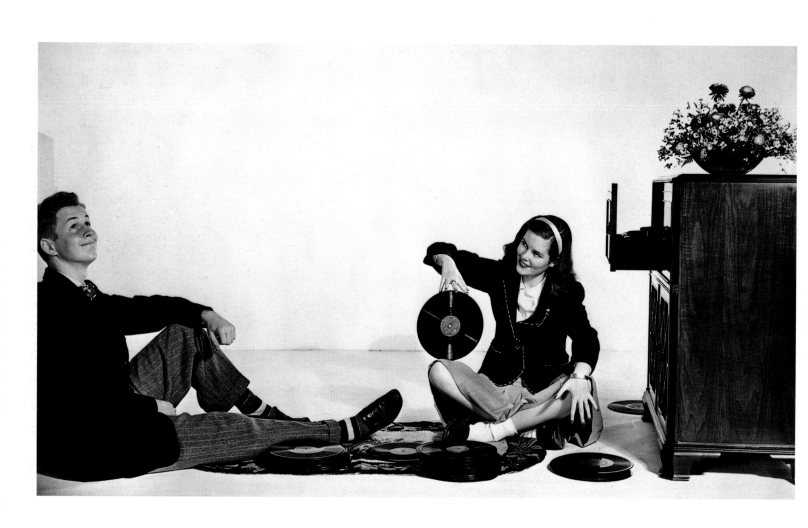

PLATE 21 Columbia Records, 1946

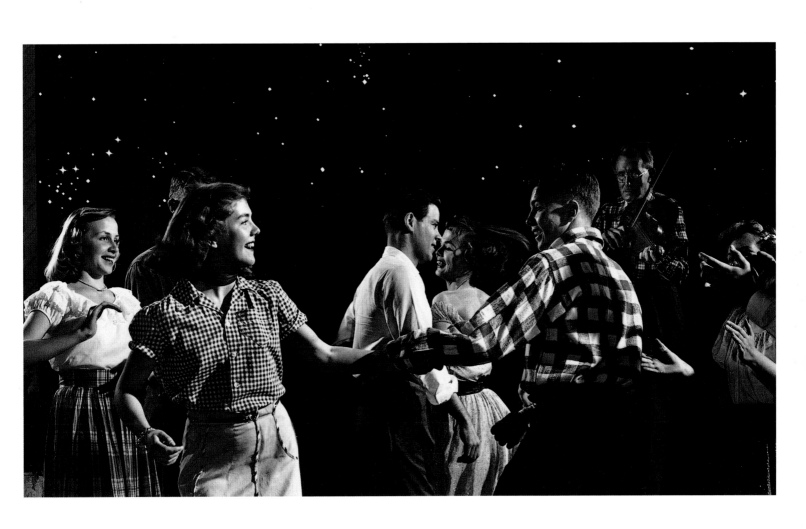

PLATE 22 Hires Root Beer, 1950

PLATE 23 Pepsi-Cola, c. 1950

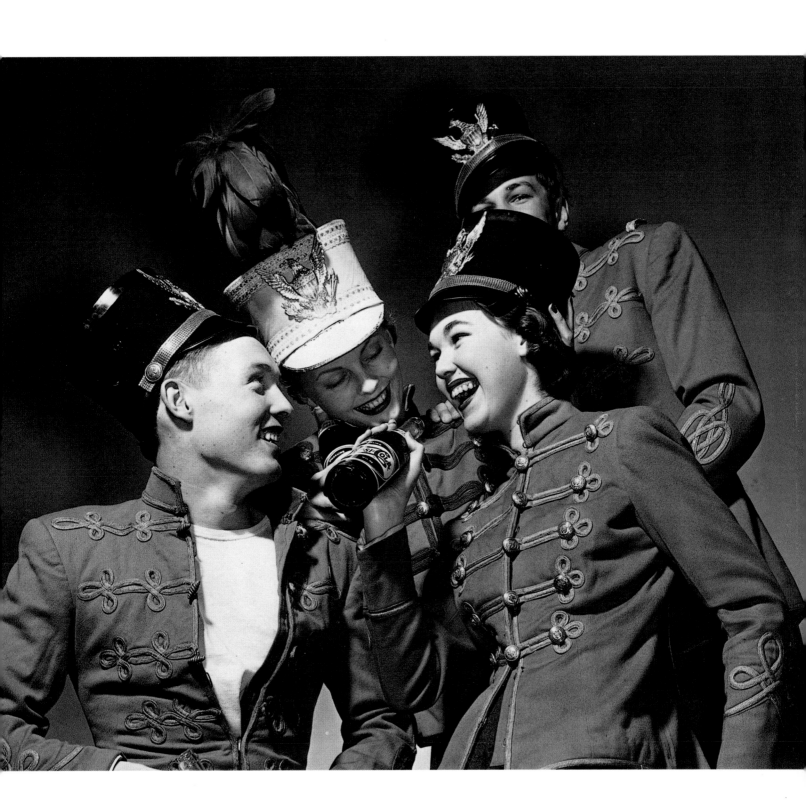

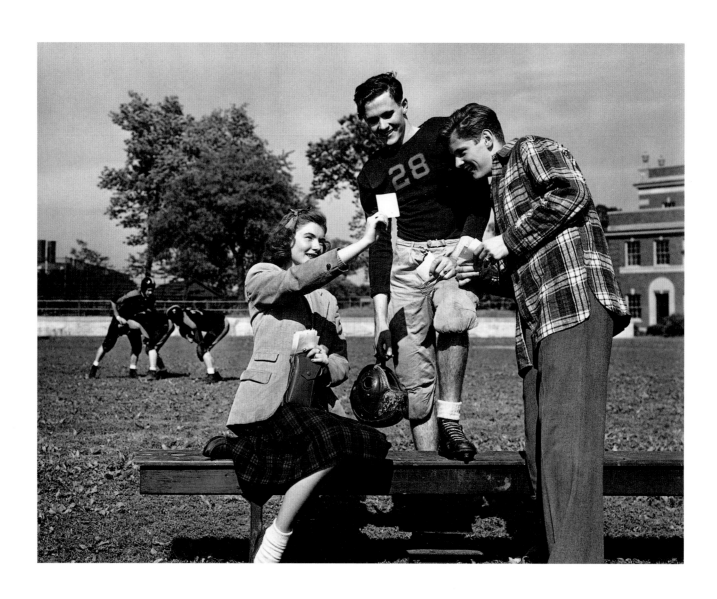

PLATE 24 Eastman Kodak, c. 1950

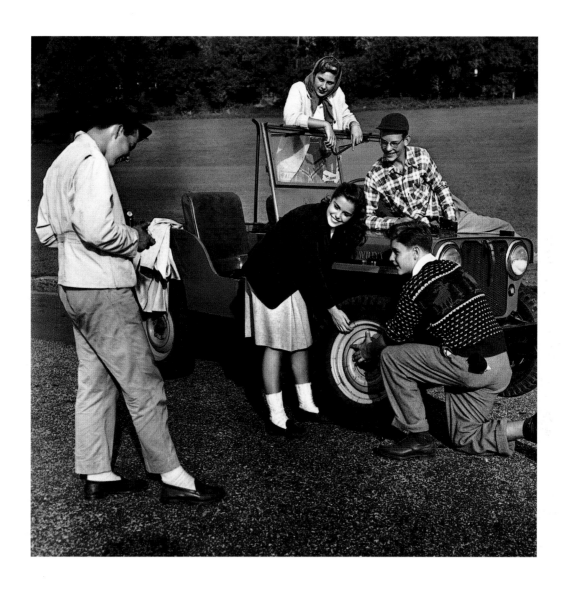

PLATE 25 Eastman Kodak, 1947

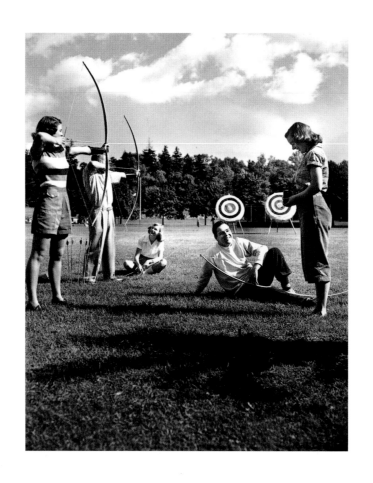

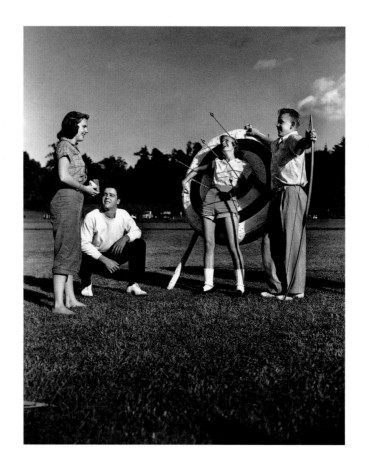

PLATE 29 Eastman Kodak, 1947

PLATES 30–49 Eastman Kodak, 1946–52 ➡

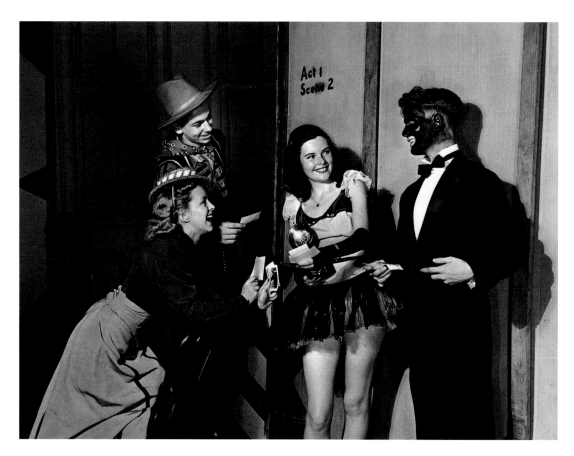

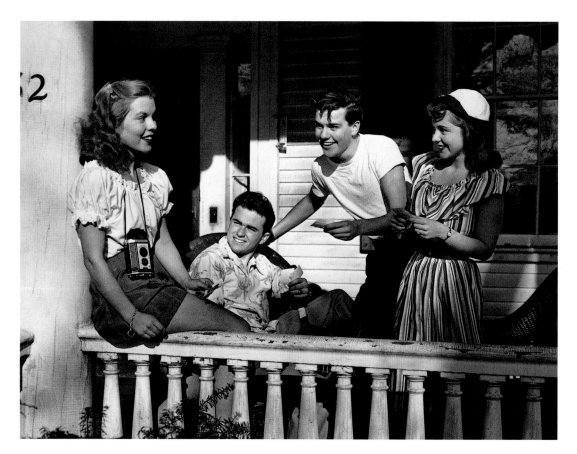

38

39

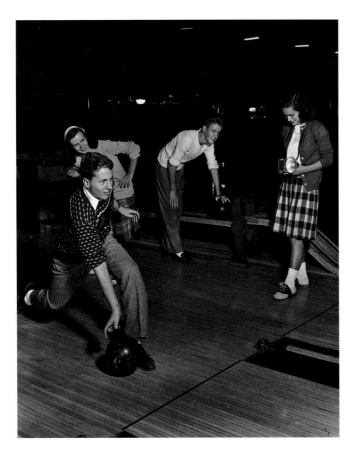

30

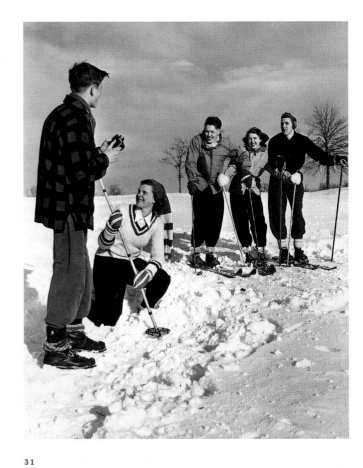

31

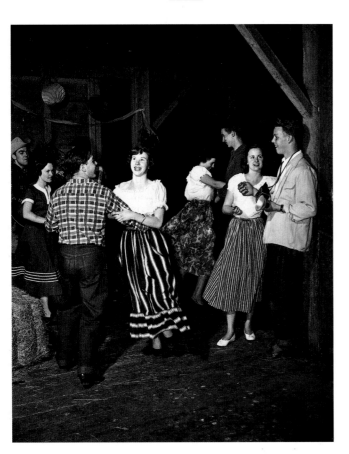

32

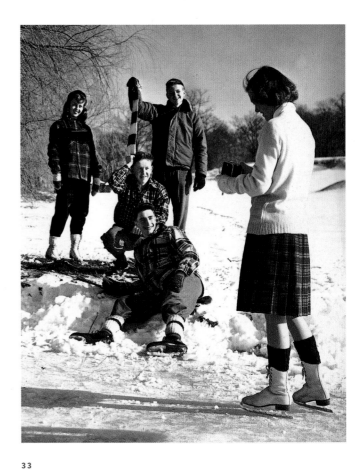

33

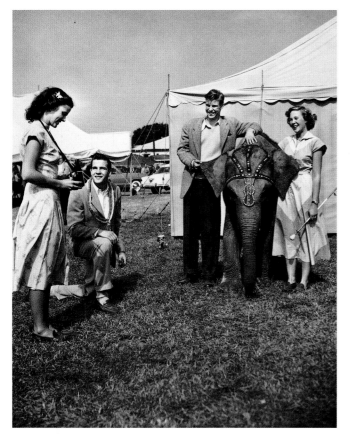

34

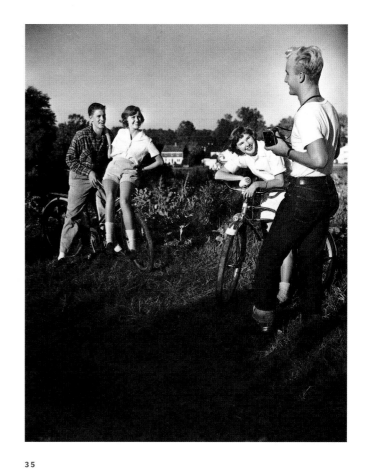

35

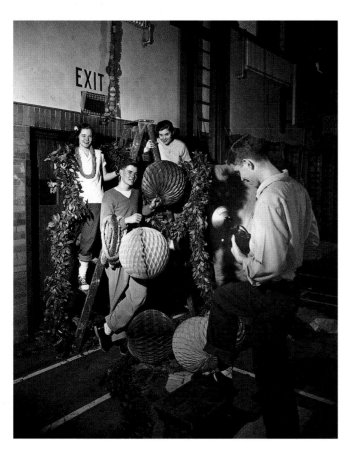

36

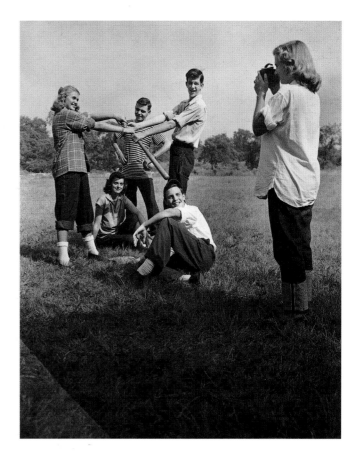

37

44

45

42

43

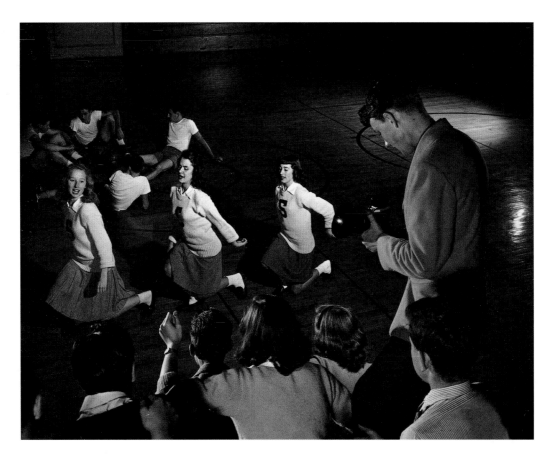

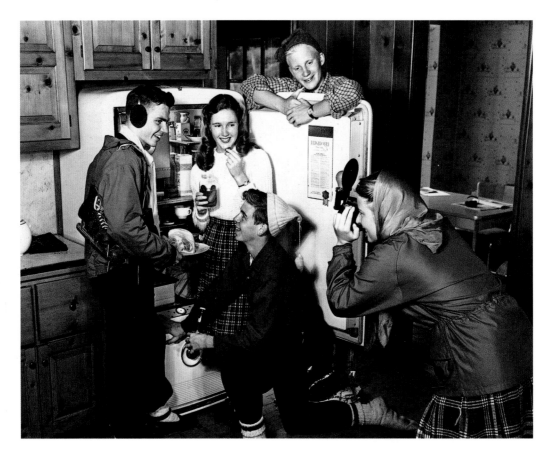

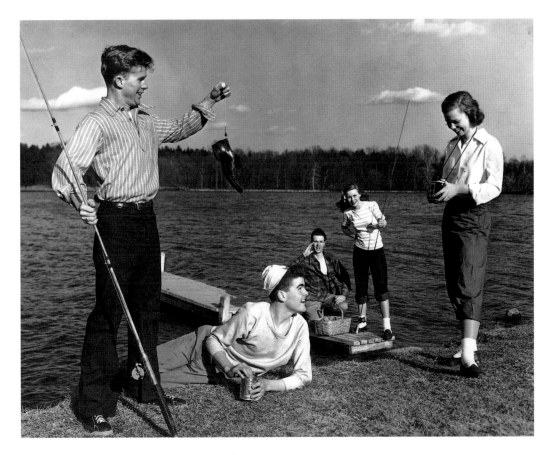

48

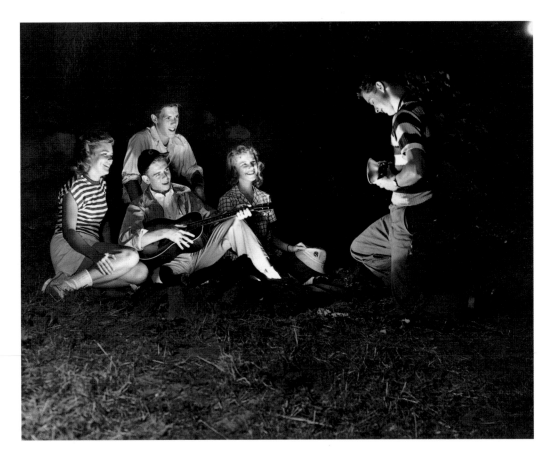

49

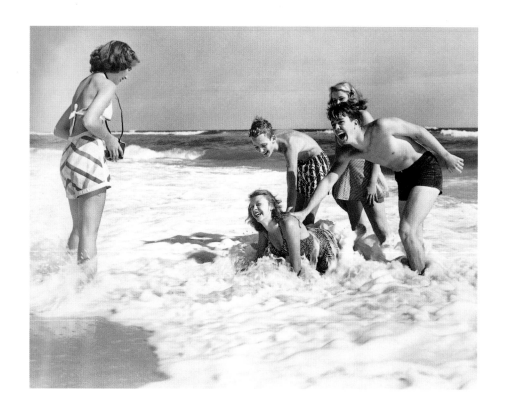

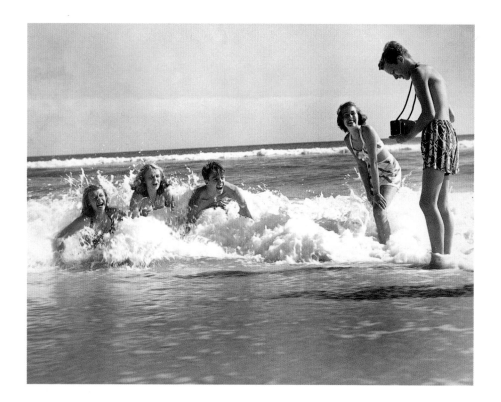

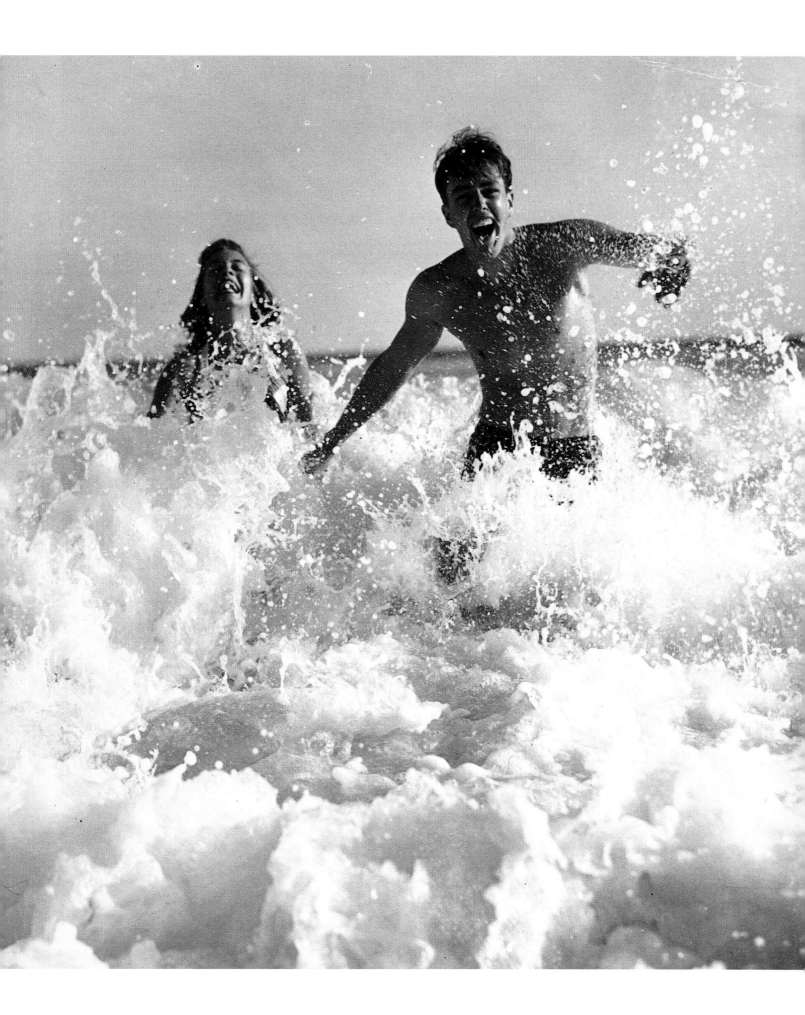

PLATE 53 Goodyear Chemical Division, c. 1947

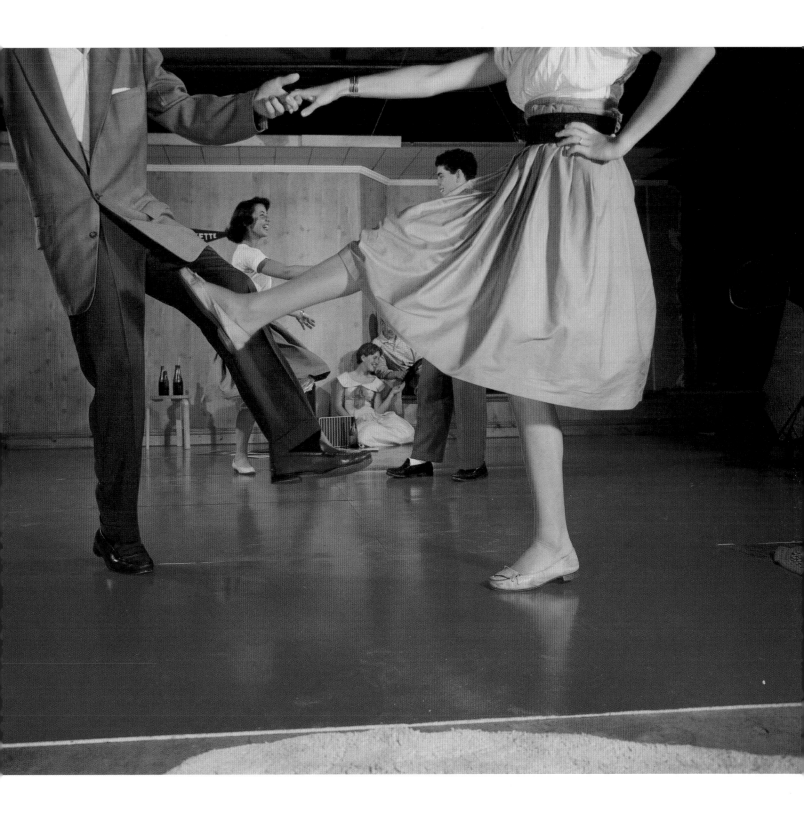

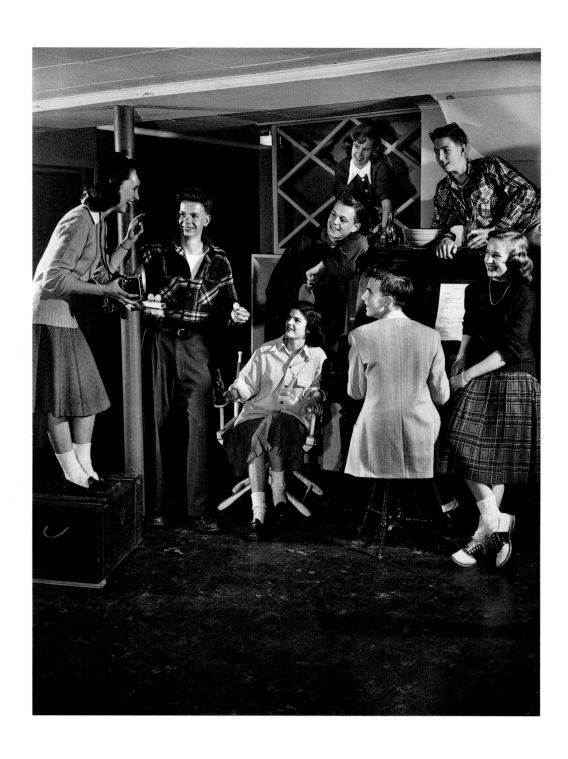

PLATE 54 Eastman Kodak, c. 1950

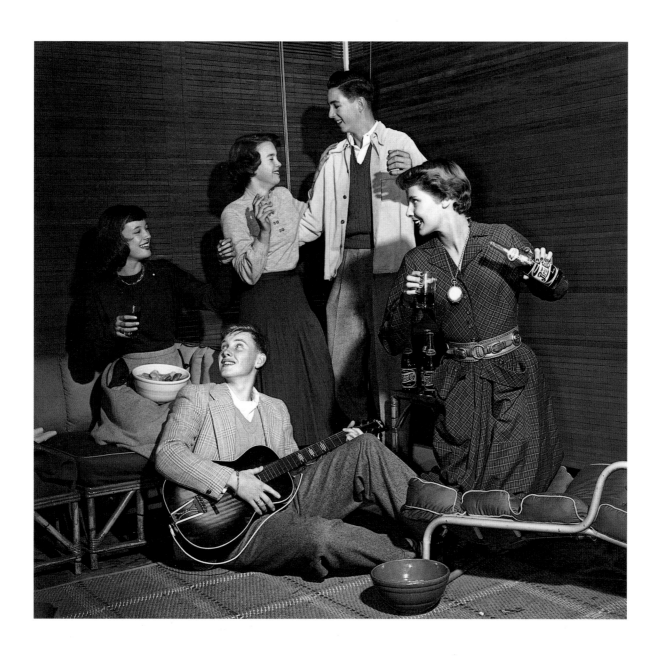

PLATE 55 Pepsi-Cola, c. 1950

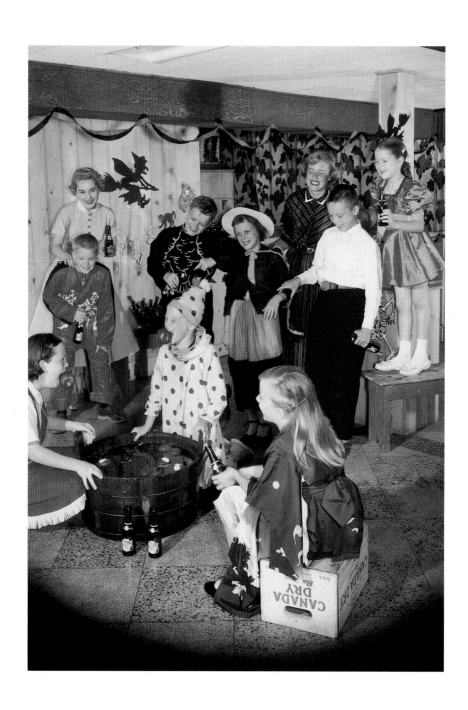

PLATE 56 Canada Dry, 1954

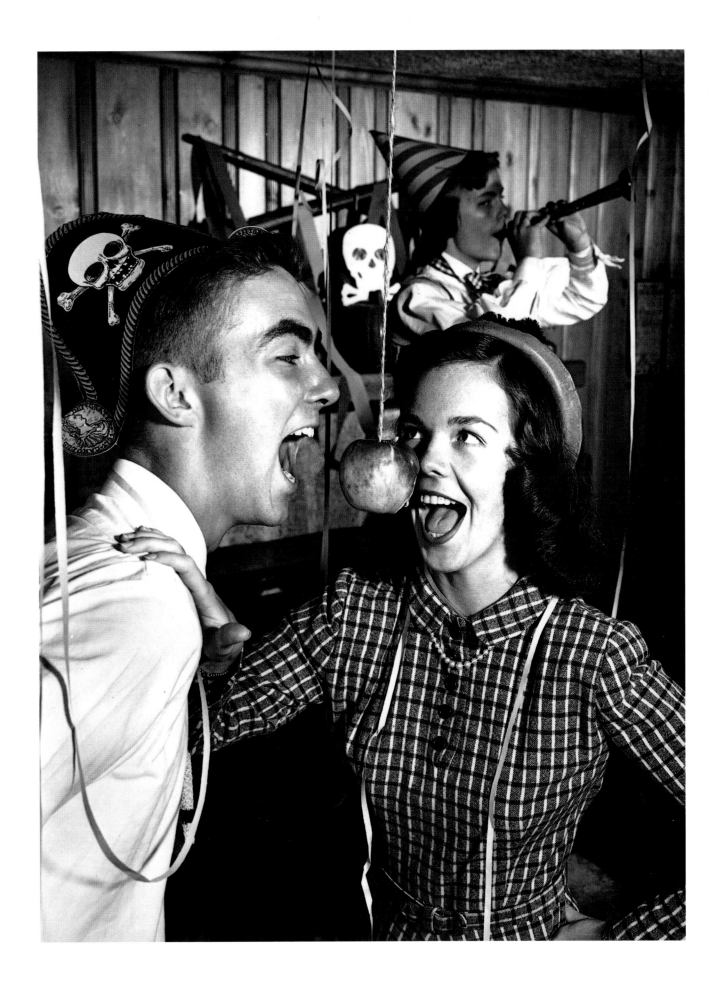

PLATE 57 Pepsodent, 1950

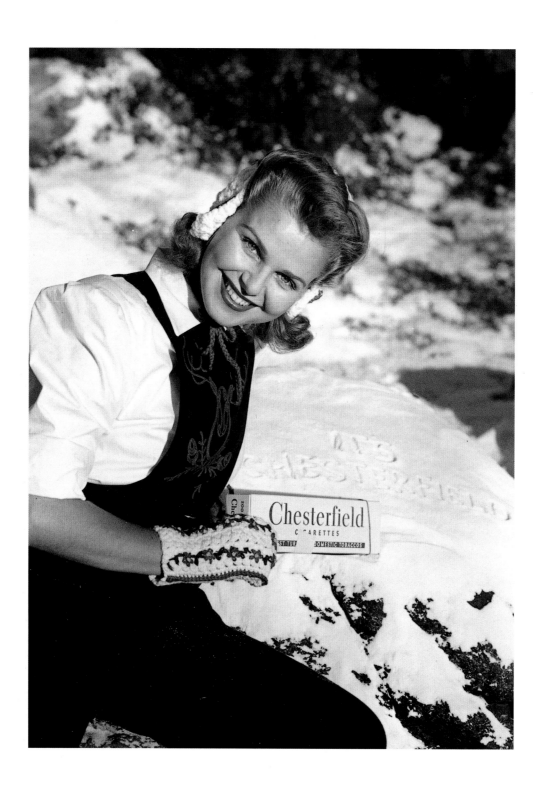

PLATE 58 Chesterfield Cigarettes, 1950s

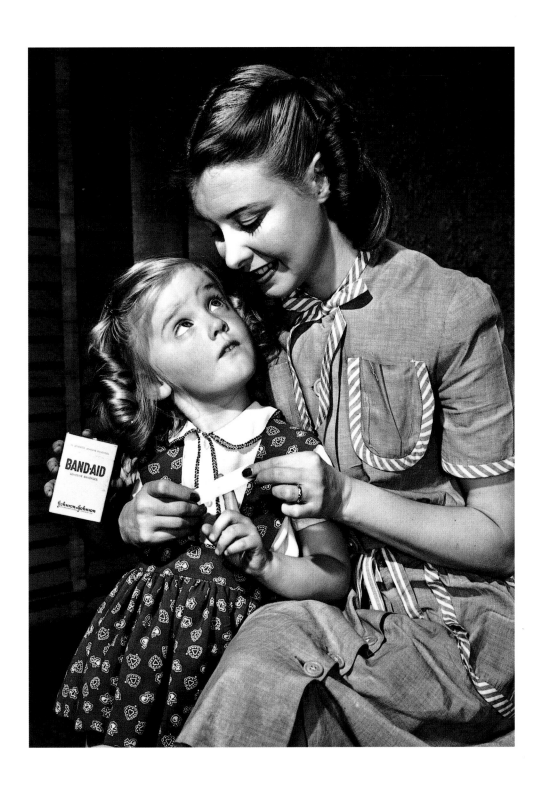

PLATE 59 Band-Aid, c. 1950

PLATE 60 Inco Nickel, 1960

PLATE 61 Sunshine Biscuit, 1953

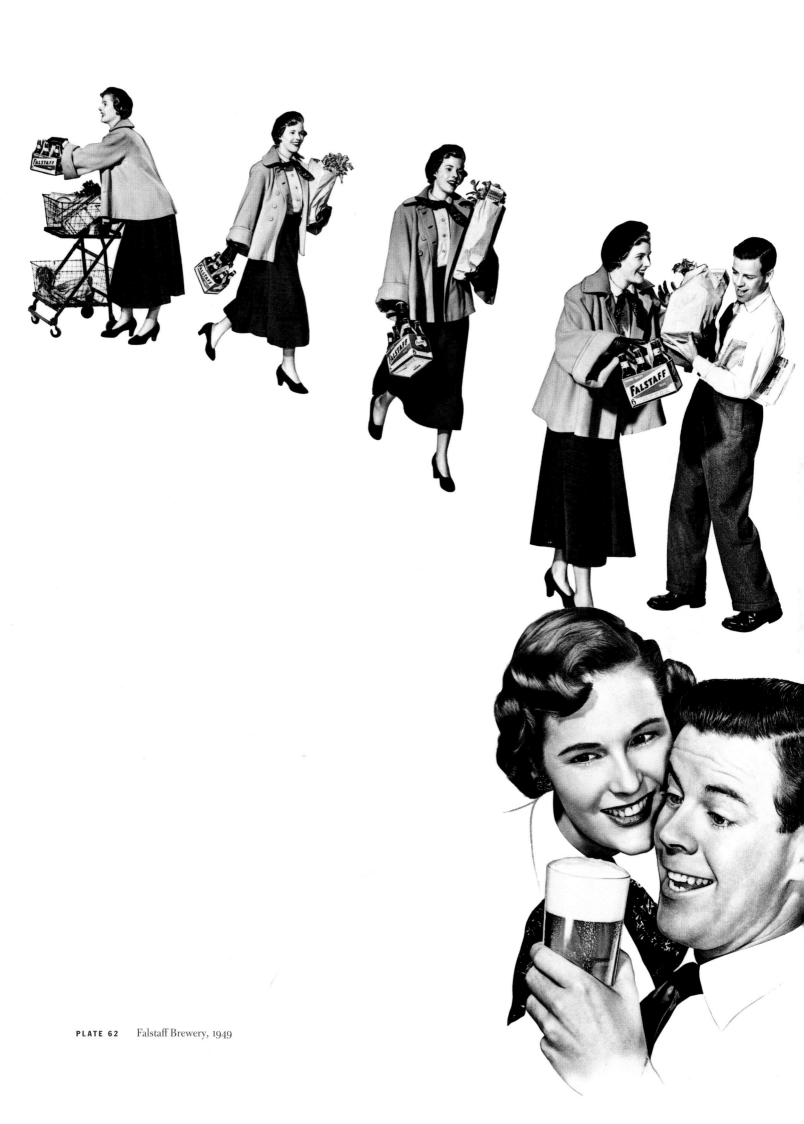

PLATE 62 Falstaff Brewery, 1949

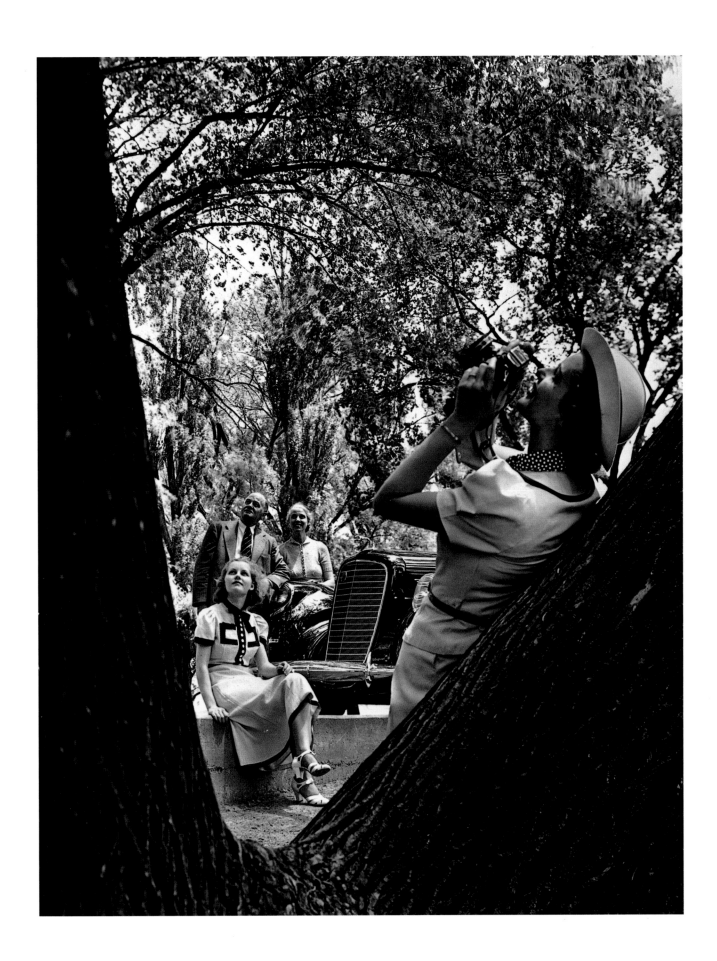

PLATES 64–66 Kaiser-Frazer, 1949

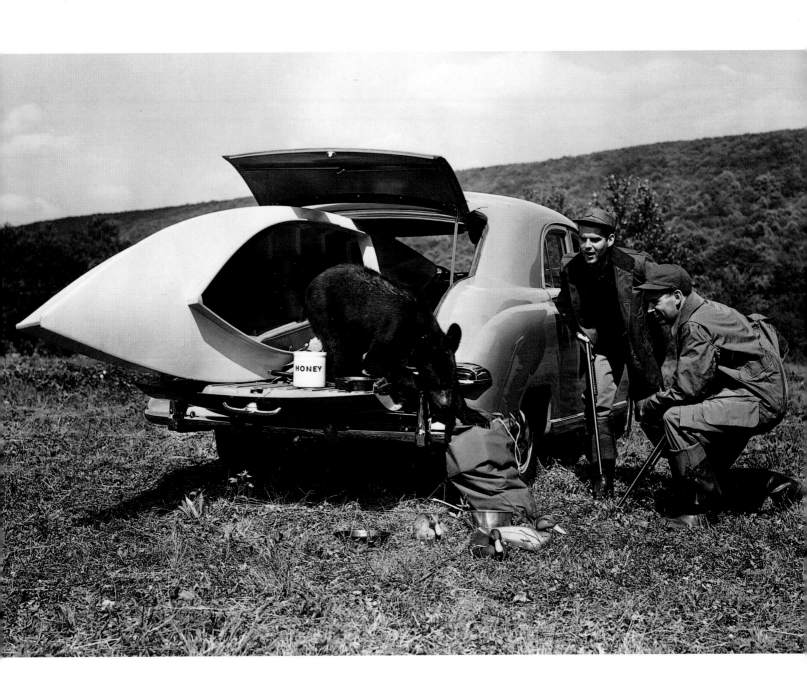

PLATE 67 Texaco, 1957 ➡

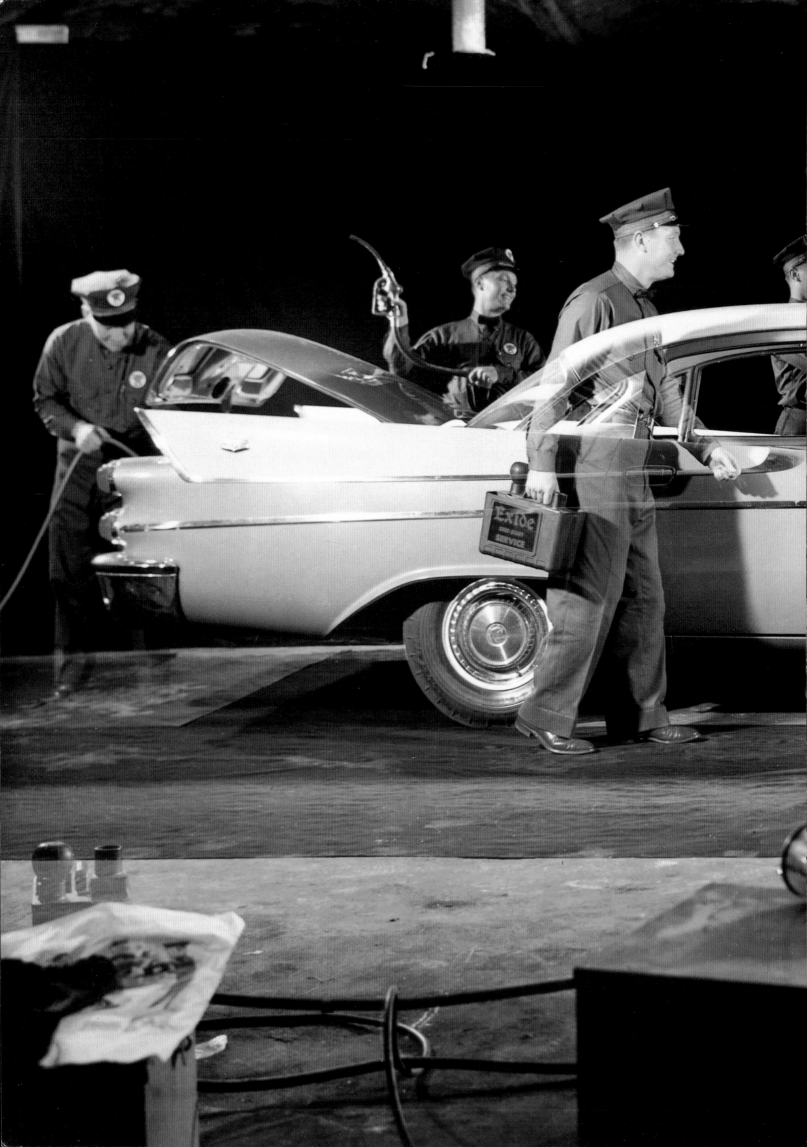

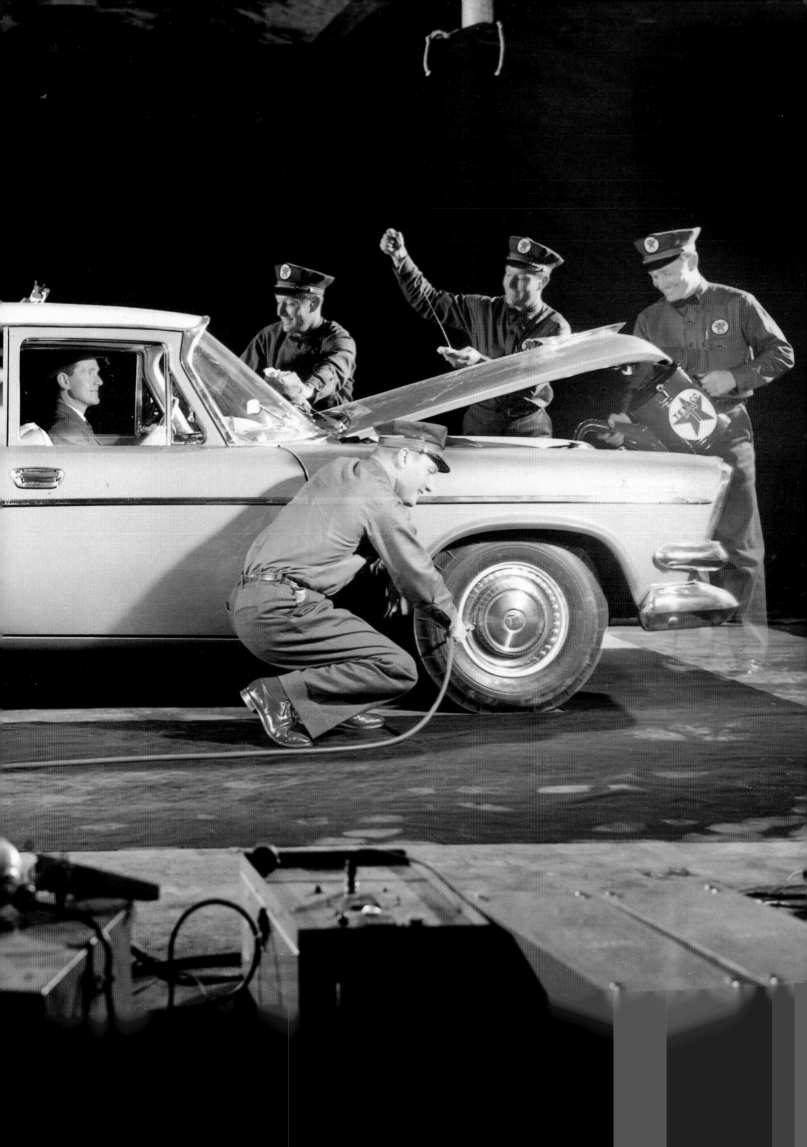

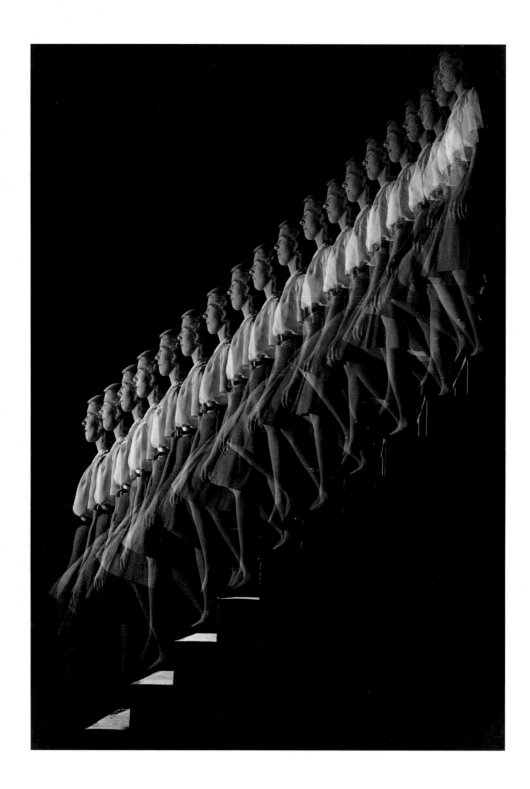

PLATE 68 *Science Illustrated* Magazine, 1946

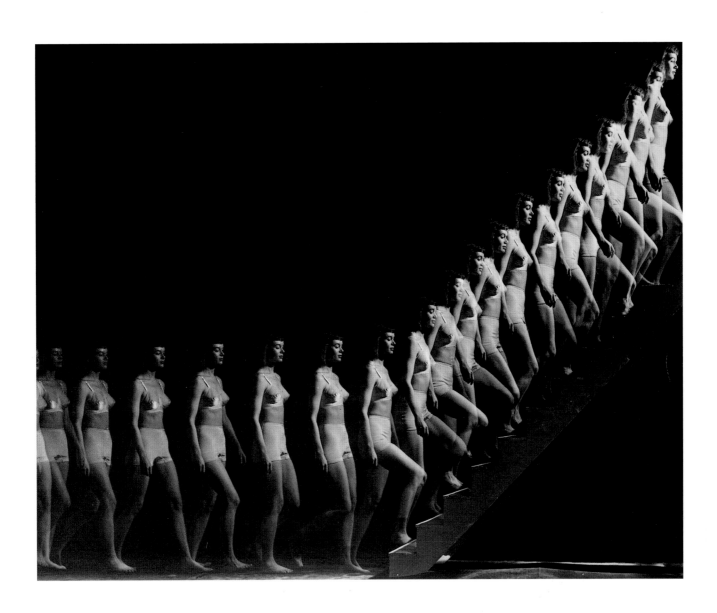

PLATE 69 Playtex, c. 1950

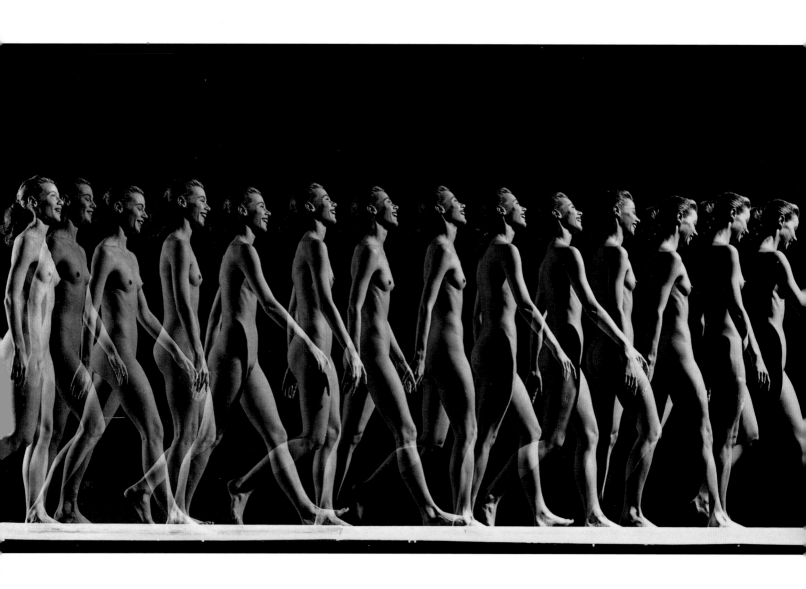

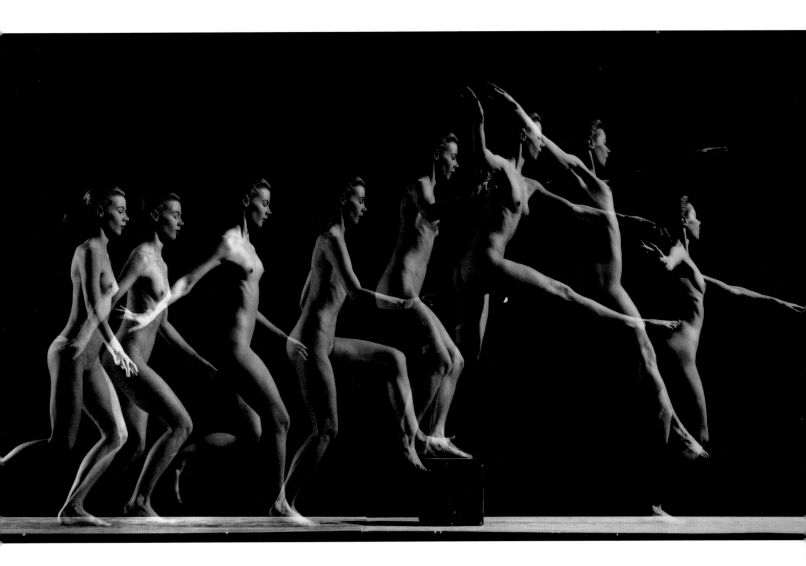

PLATE 72 Eastman Kodak, 1946

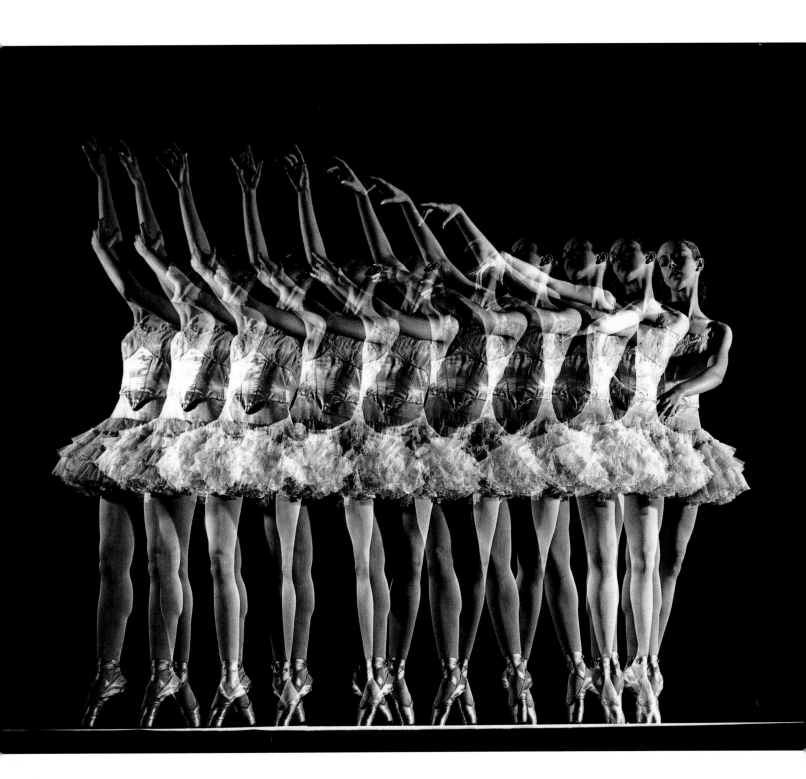

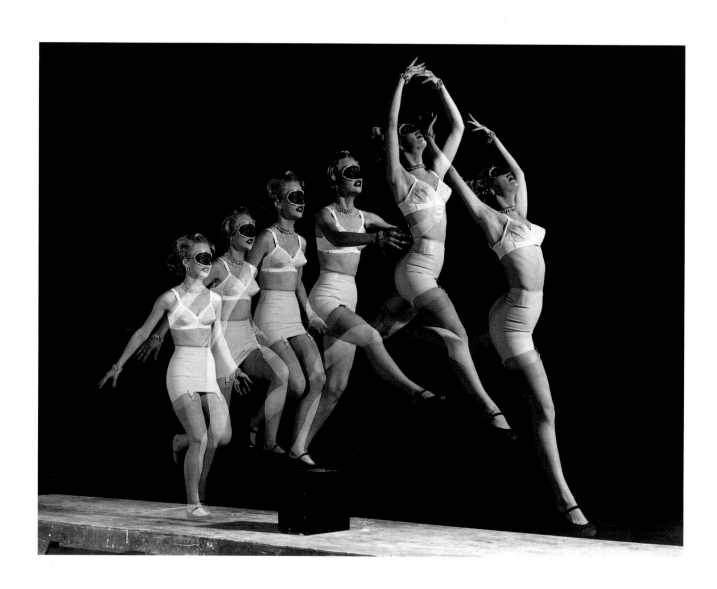

PLATE 73 Playtex, 1954

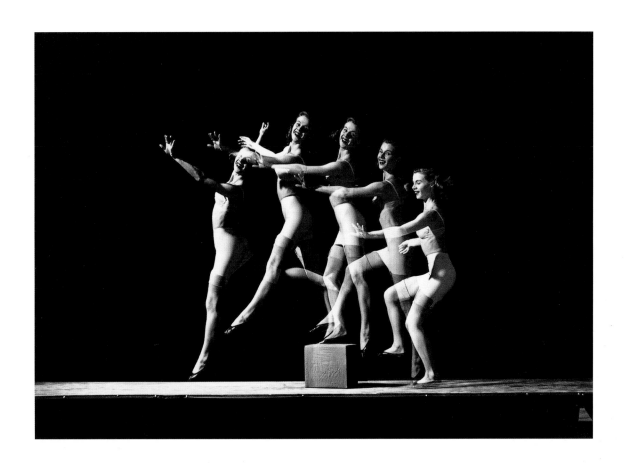

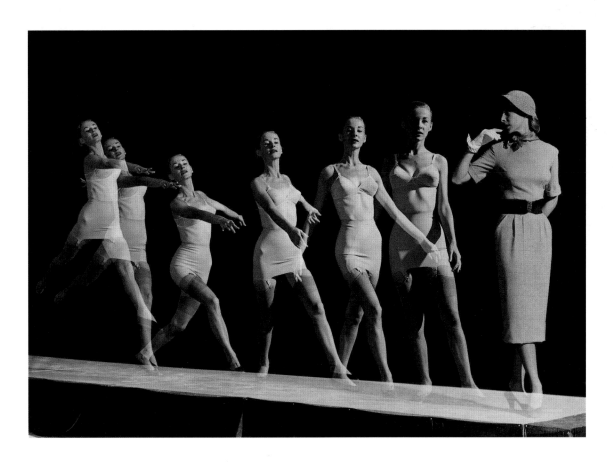

PLATE 74 Playtex, 1950
PLATE 75 Playtex, 1952

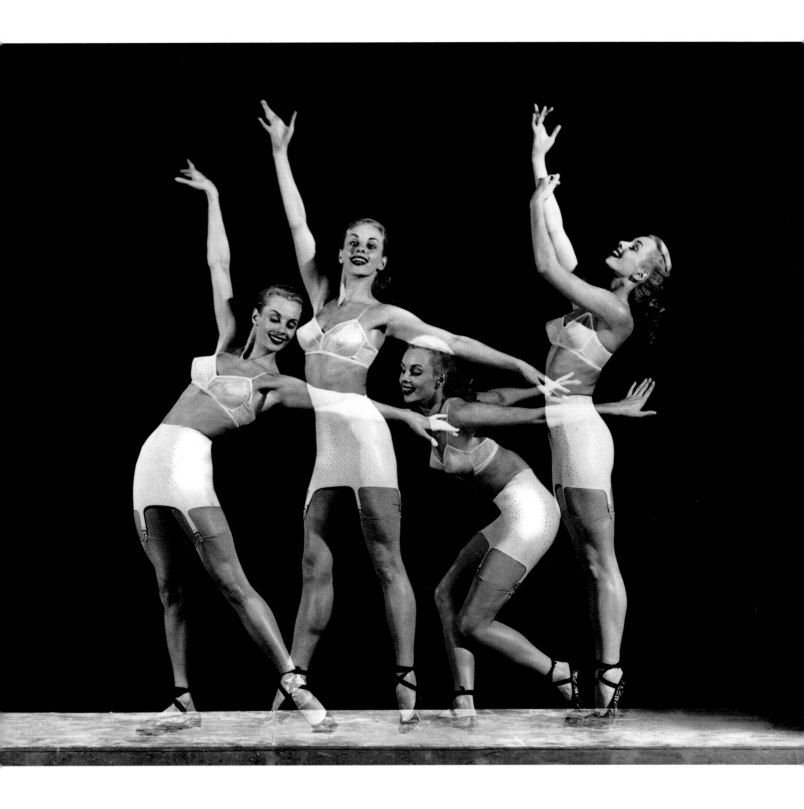

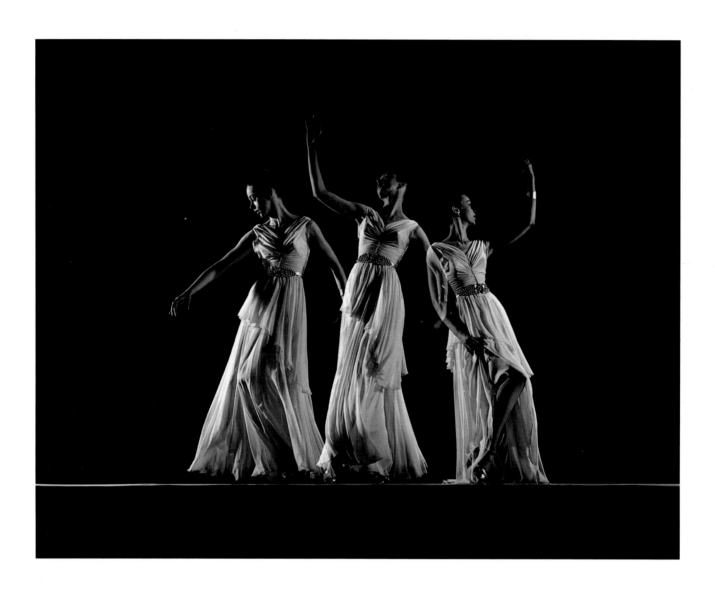

PLATES 77–78 Vision Nylons, 1940s

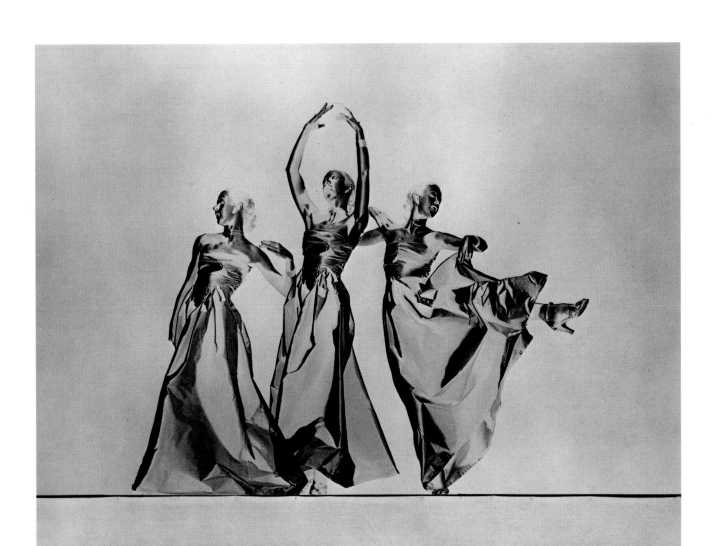

PLATE 79 Playtex, 1953

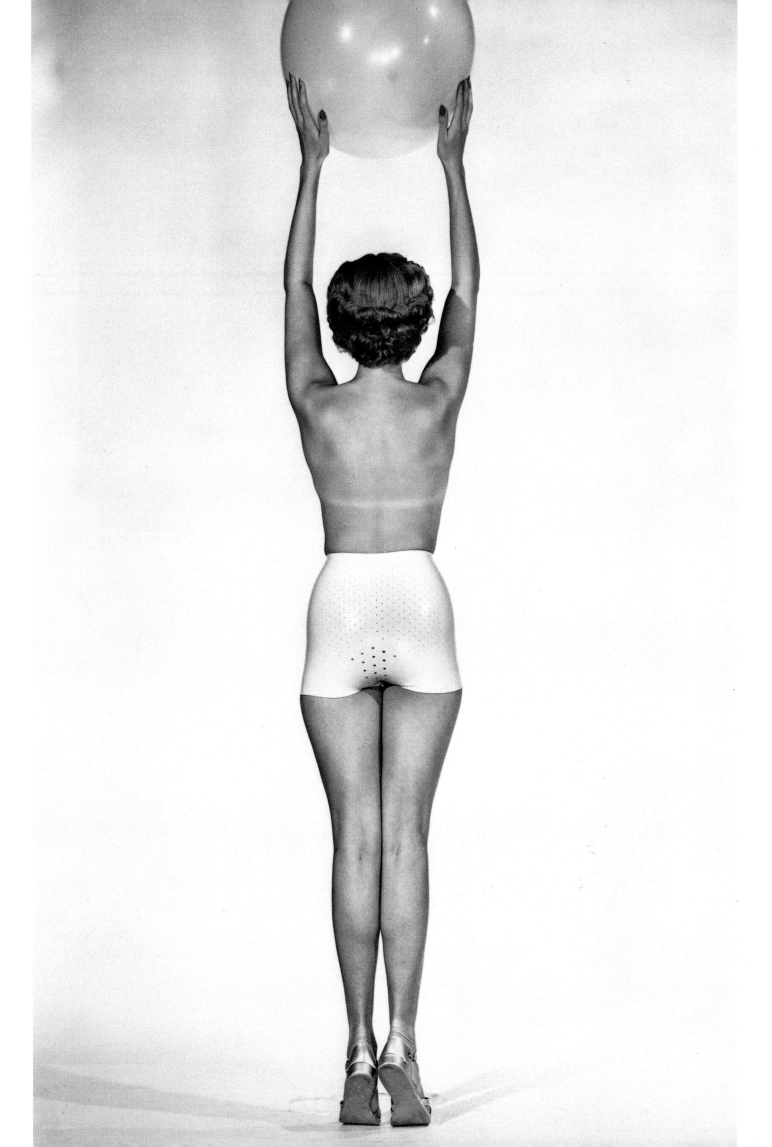

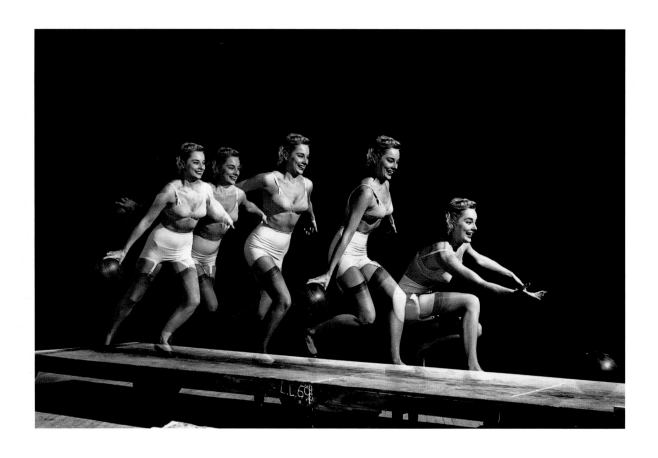

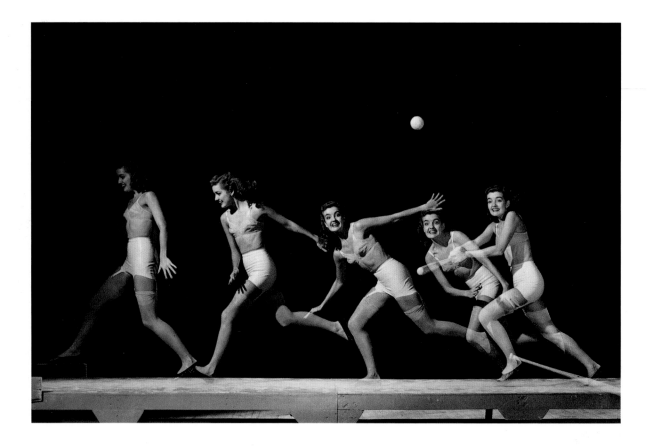

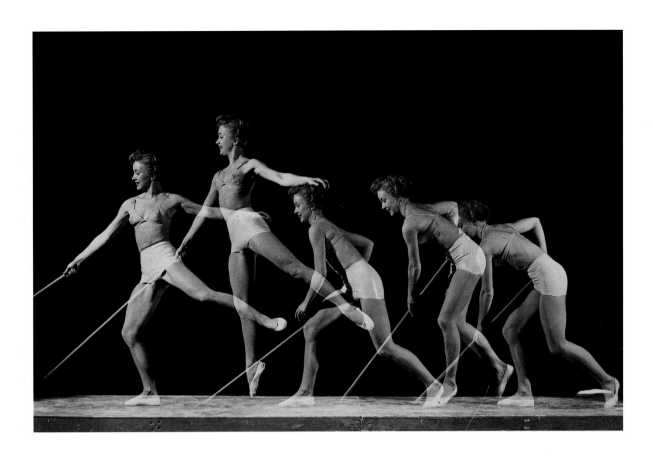

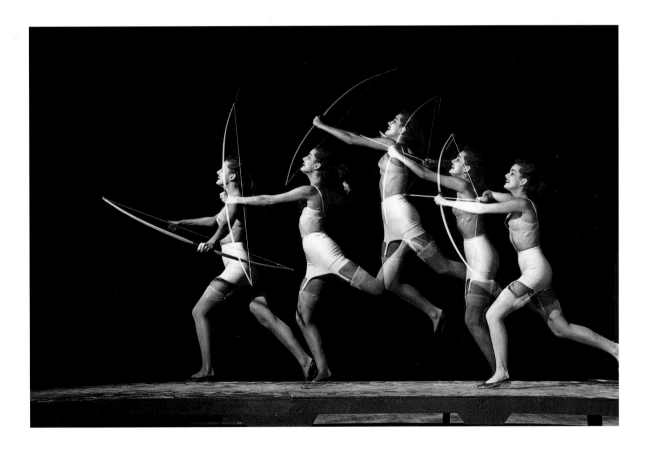

PLATE 82 Playtex, c. 1950

PLATE 83 Playtex, 1950

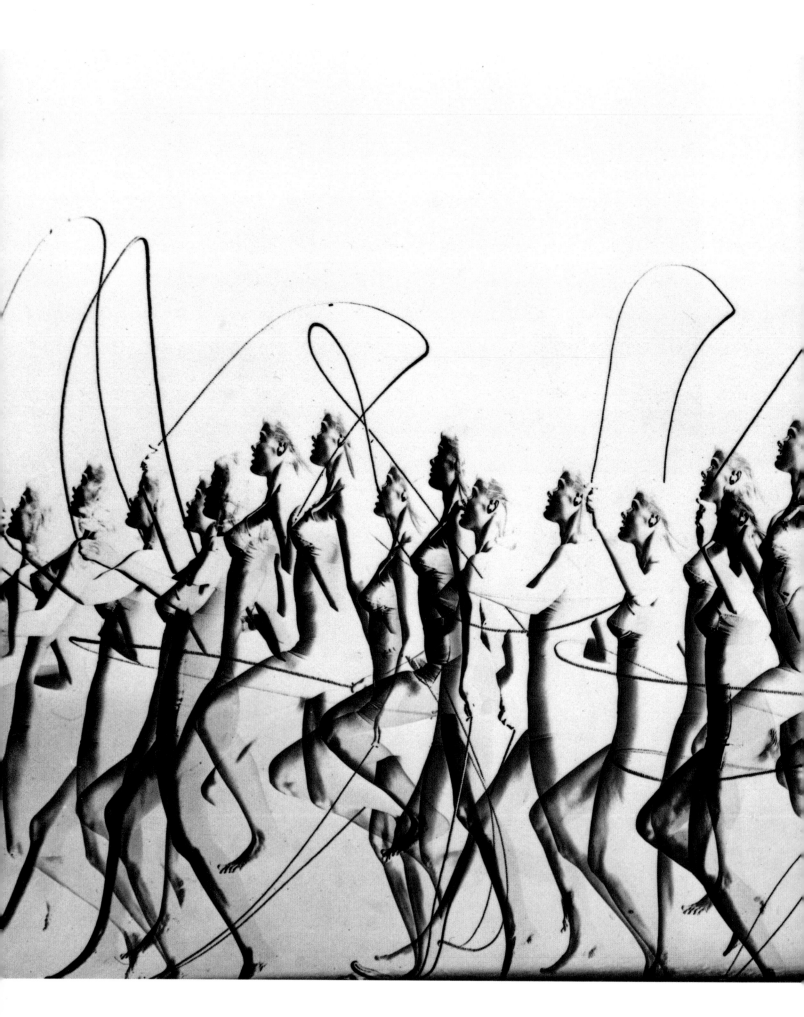

PLATE 84 Playtex, 1946

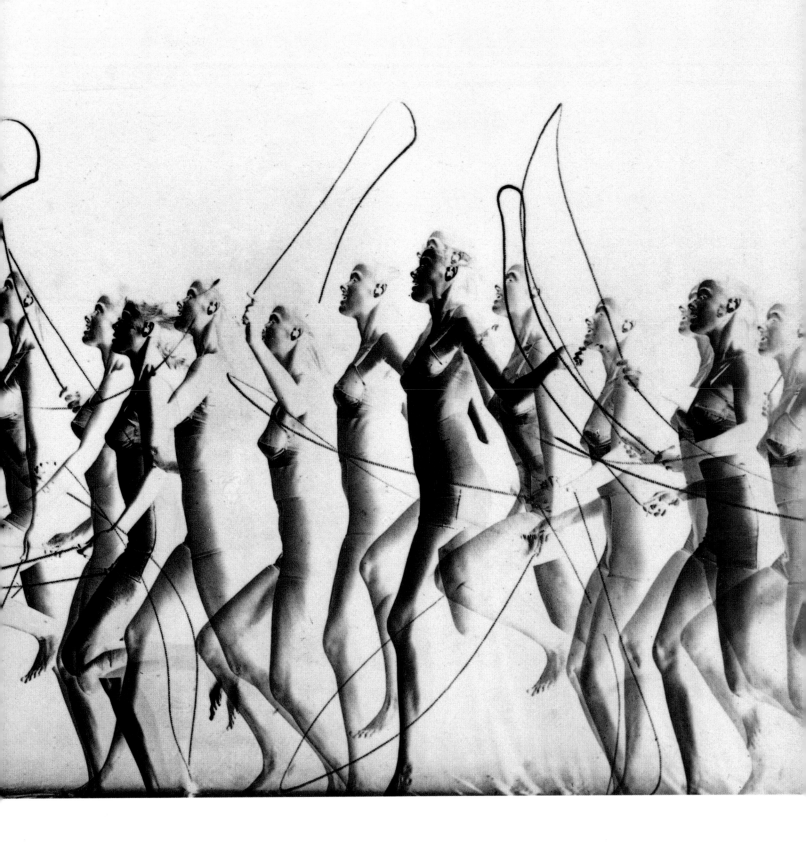

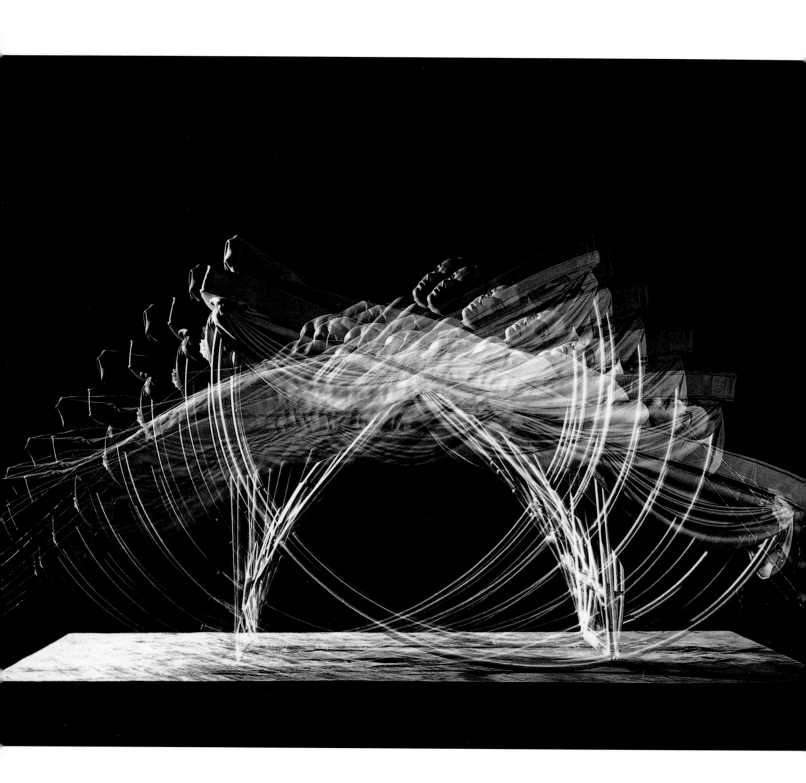

PLATE 85 *Harper's Bazaar* Magazine, 1946

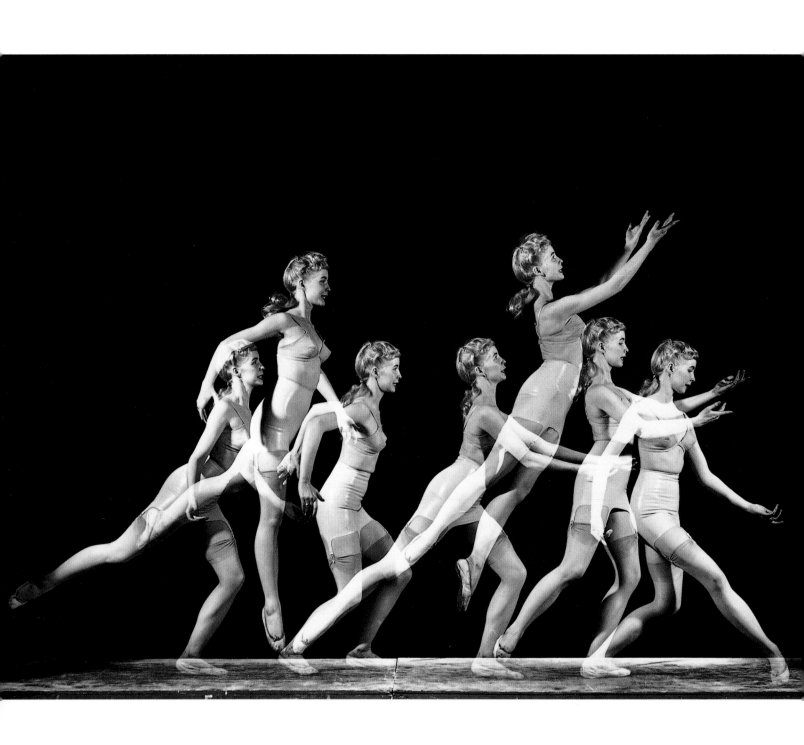

PLATE 86 Playtex, 1950

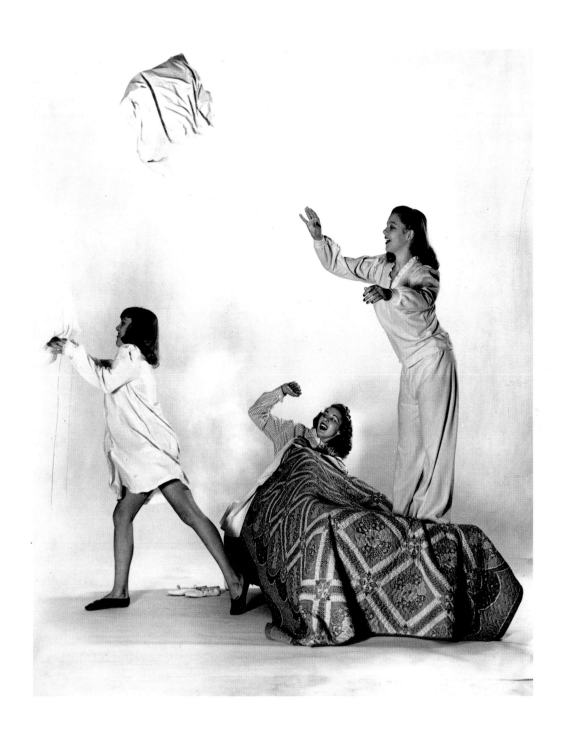

PLATE 87 *Harper's Bazaar* Magazine, 1946

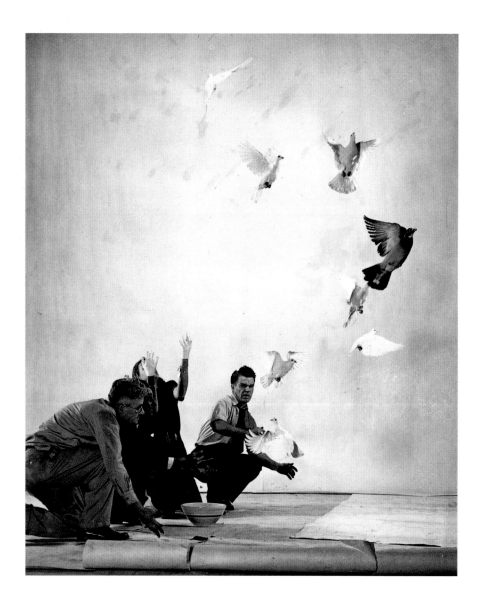

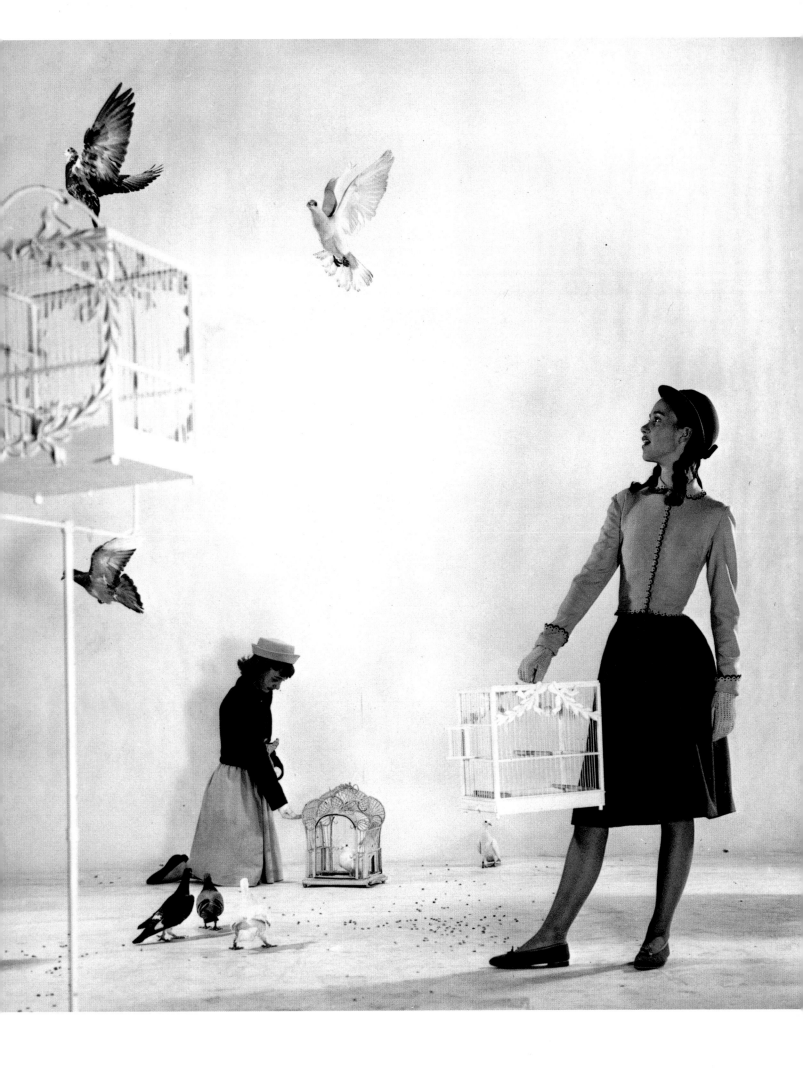

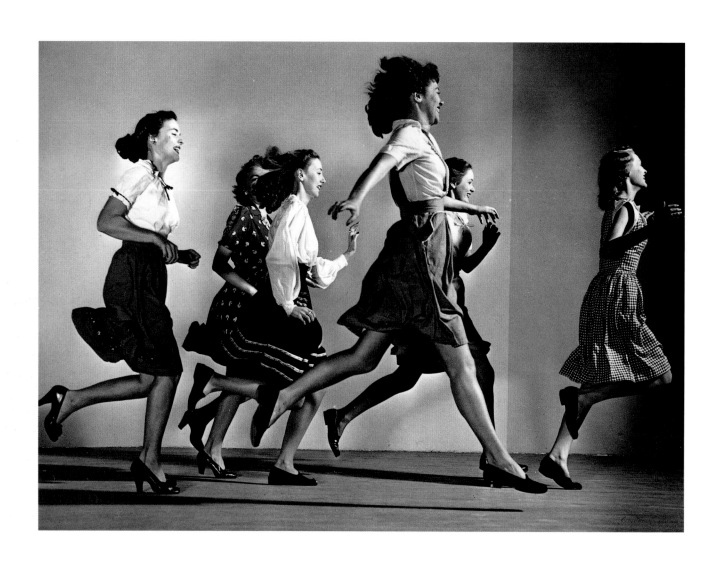

PLATES 90–91 Model tests, 1951

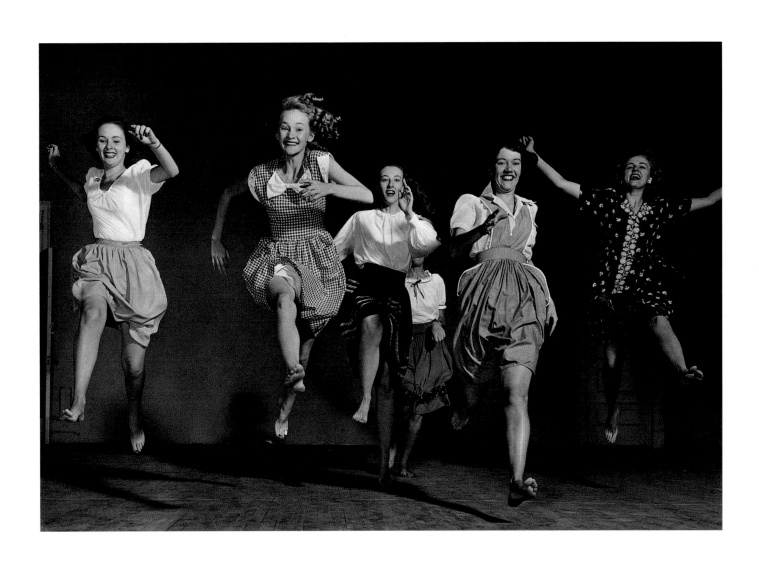

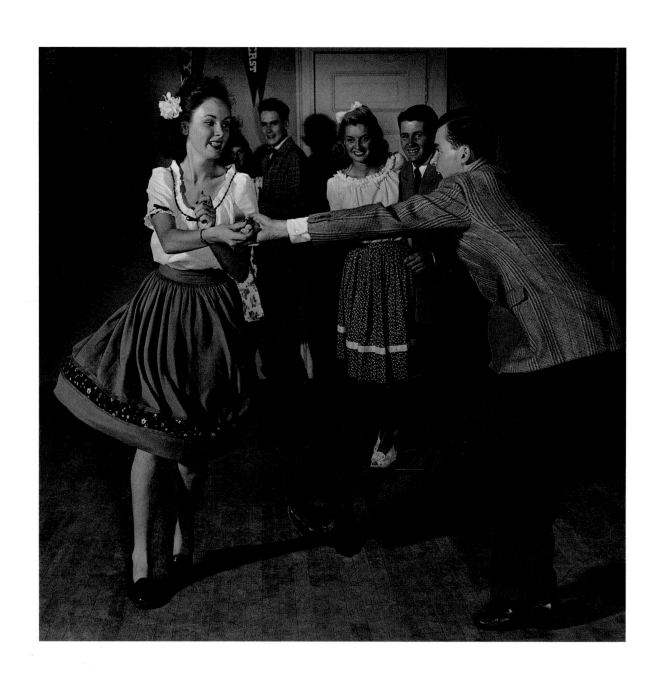

PLATE 92 Fresh Deodorant, 1945

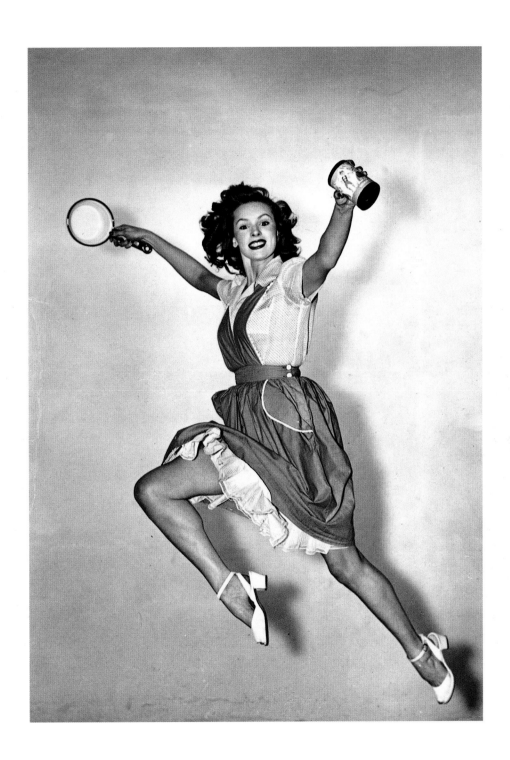

PLATE 93 Keetman and Sons, 1939

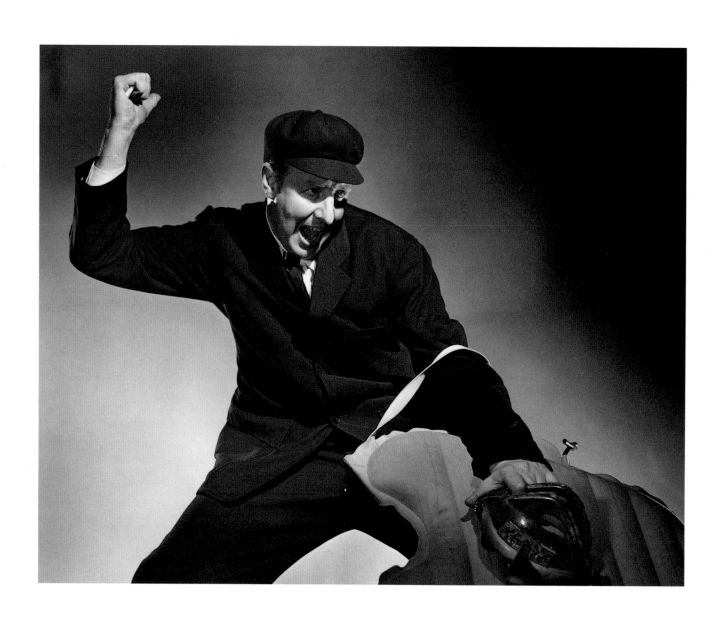

PLATES 94-95 Texaco, 1940

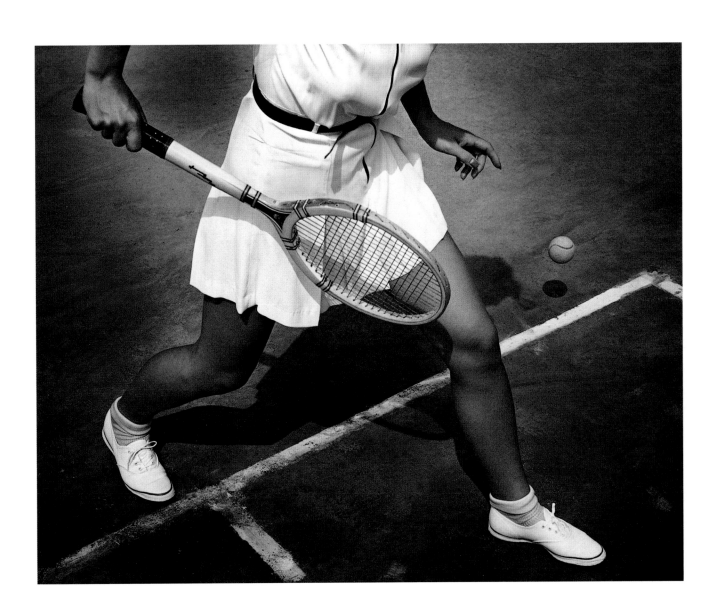

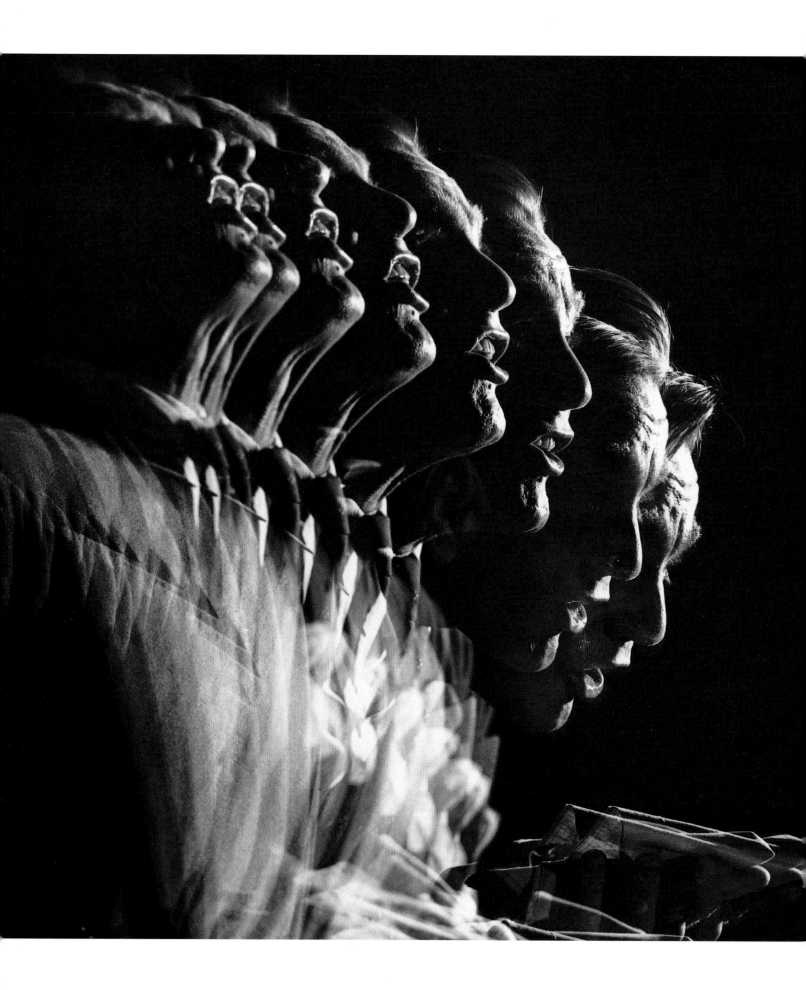

PLATE 96 *The American Magazine,* 1949

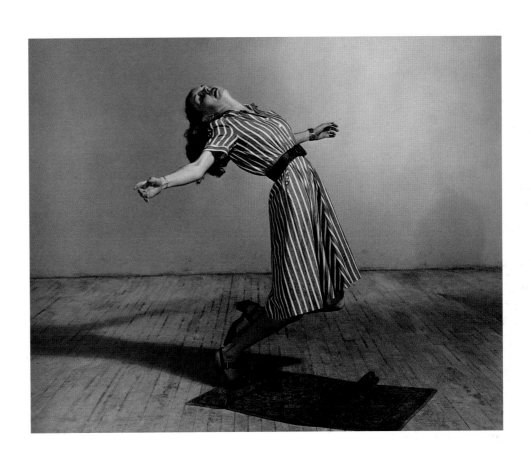

PLATE 97 DuPont, 1943

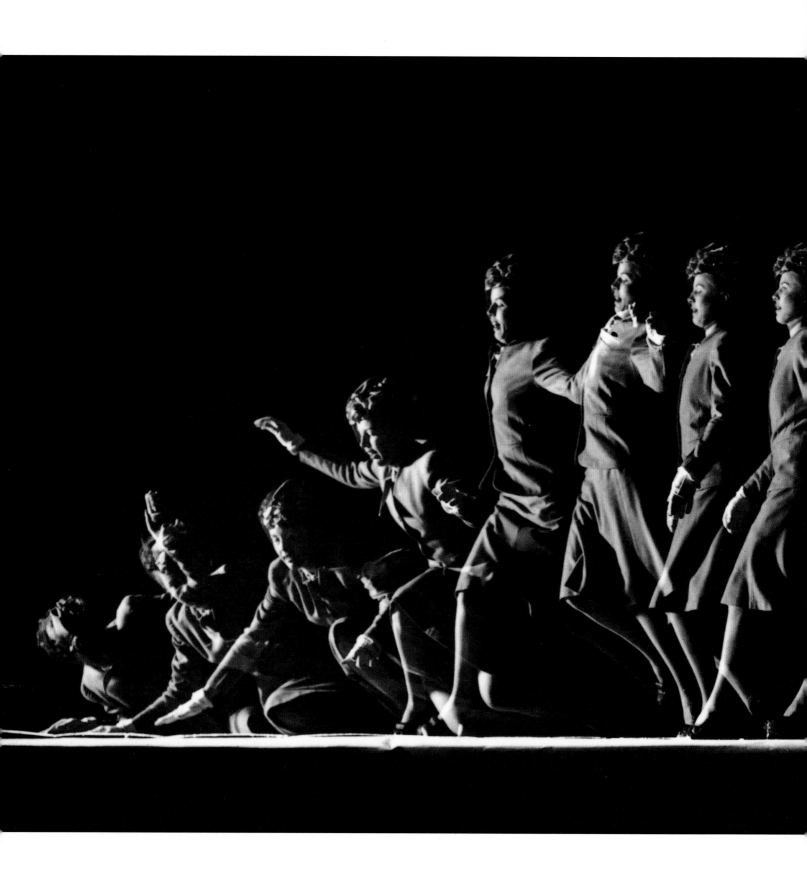

PLATE 98 Unknown client, 1940s

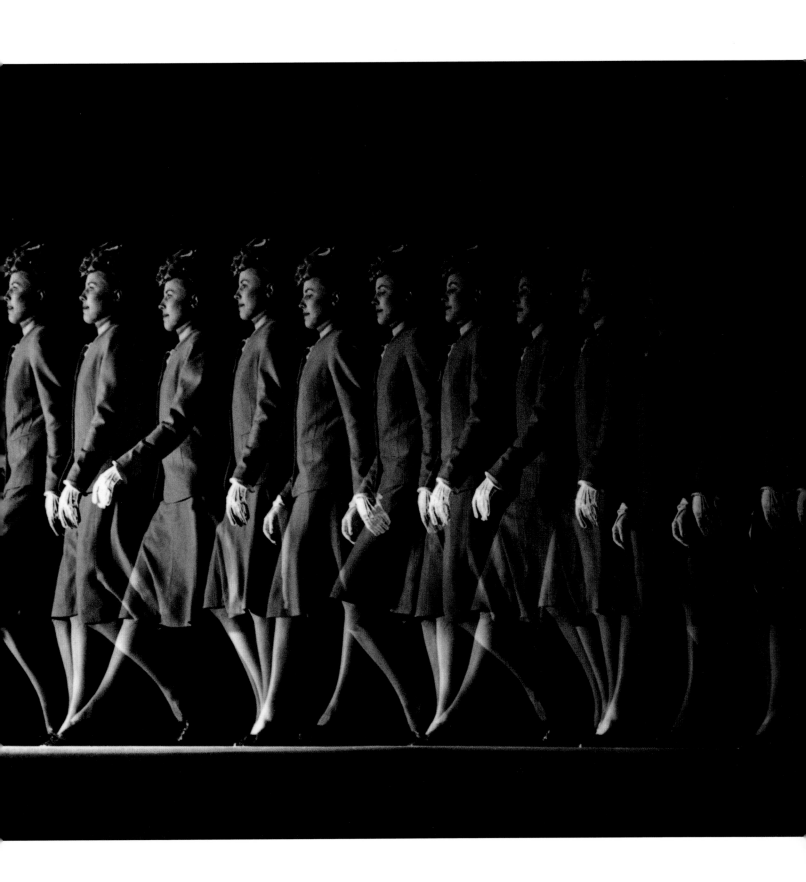

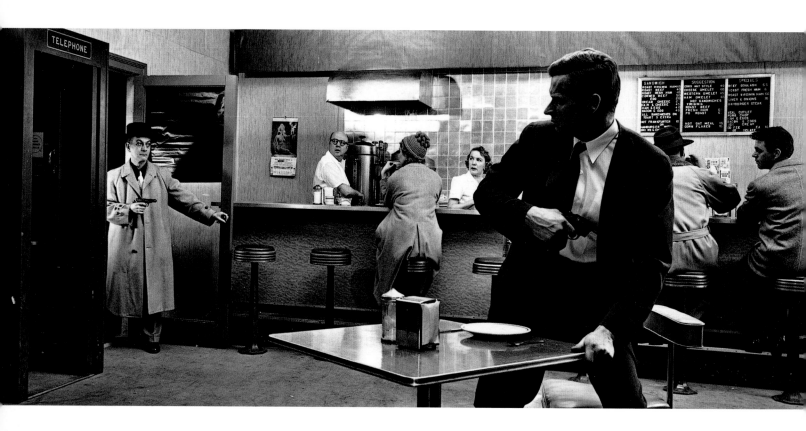

PLATE 99 Eastman Kodak, 1954

PLATE 100 Unknown client, 1940s

PLATE 101 Band-Aid, c. 1950

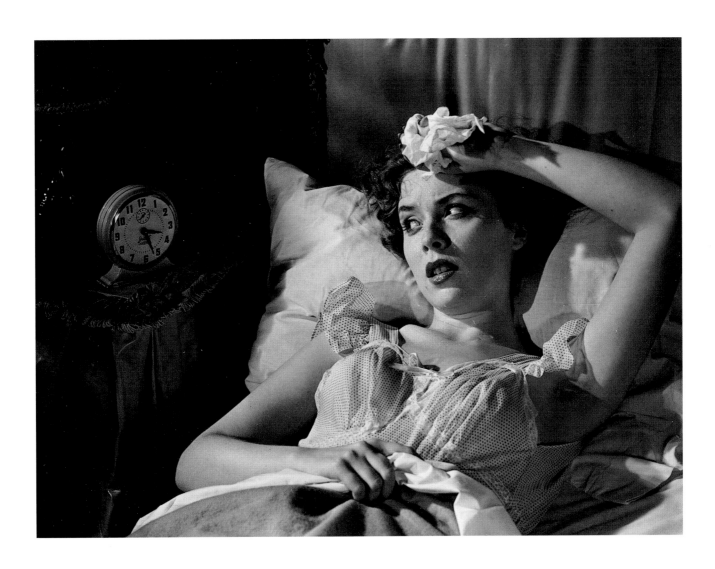

PLATE 102 Playtex, 1940s

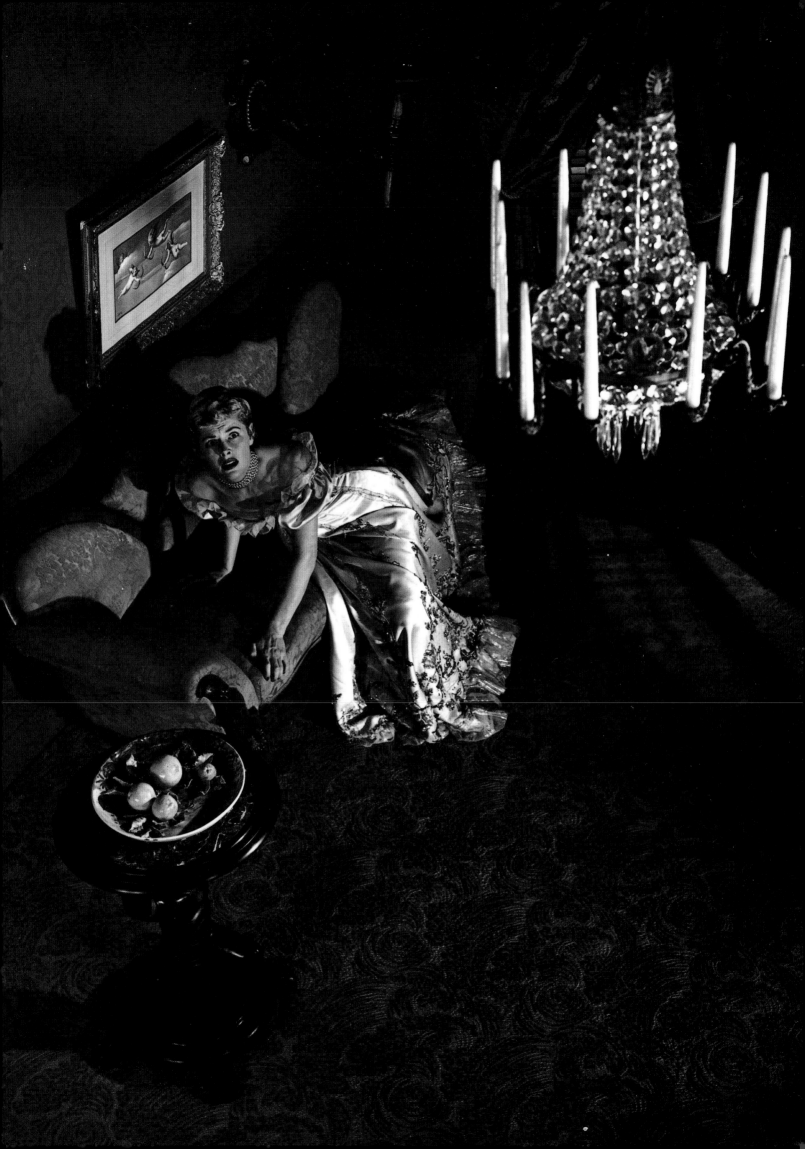

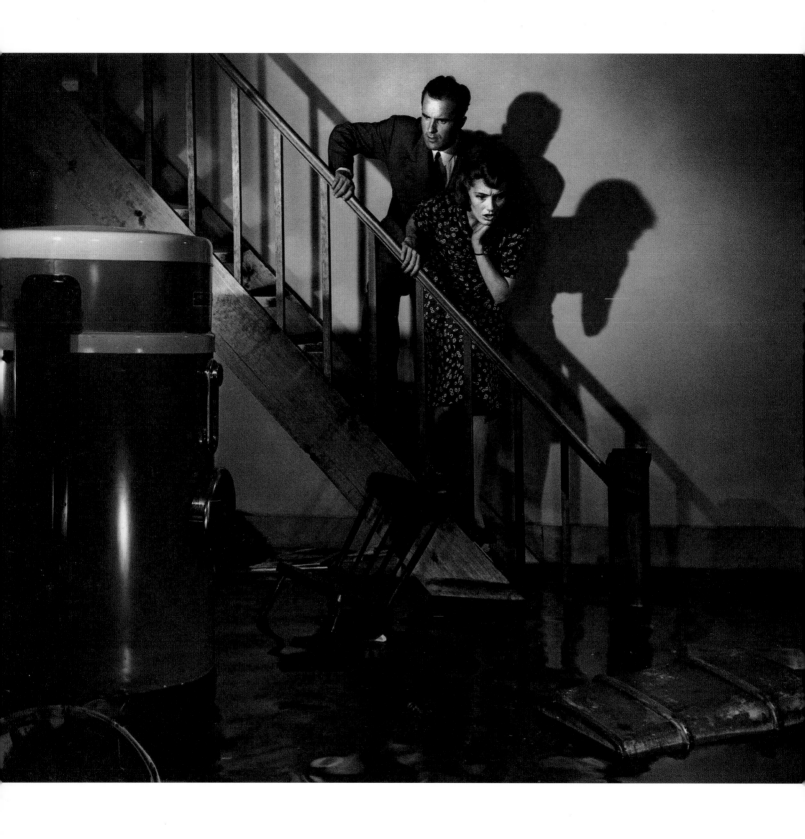

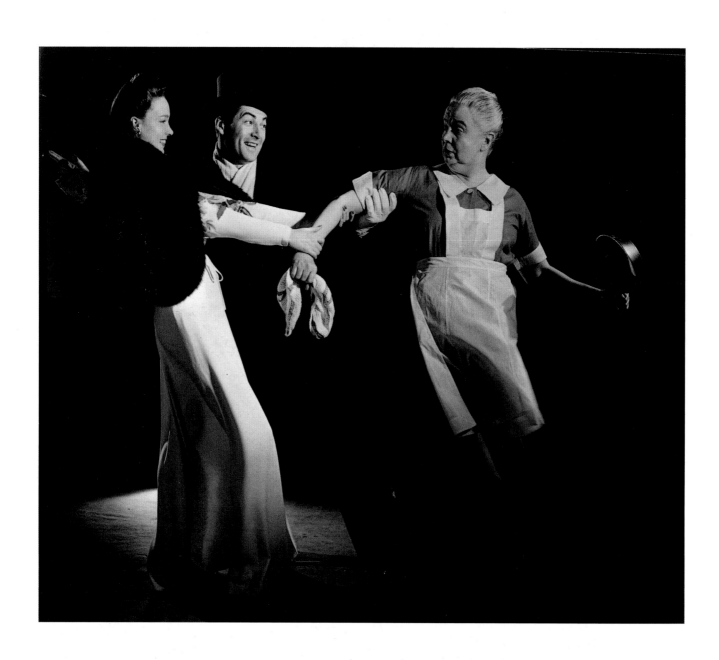

PLATE 105 Texaco, 1940

PLATE 106 Unknown client, 1940s

PLATE 107 *Cosmopolitan* Magazine, 1940s

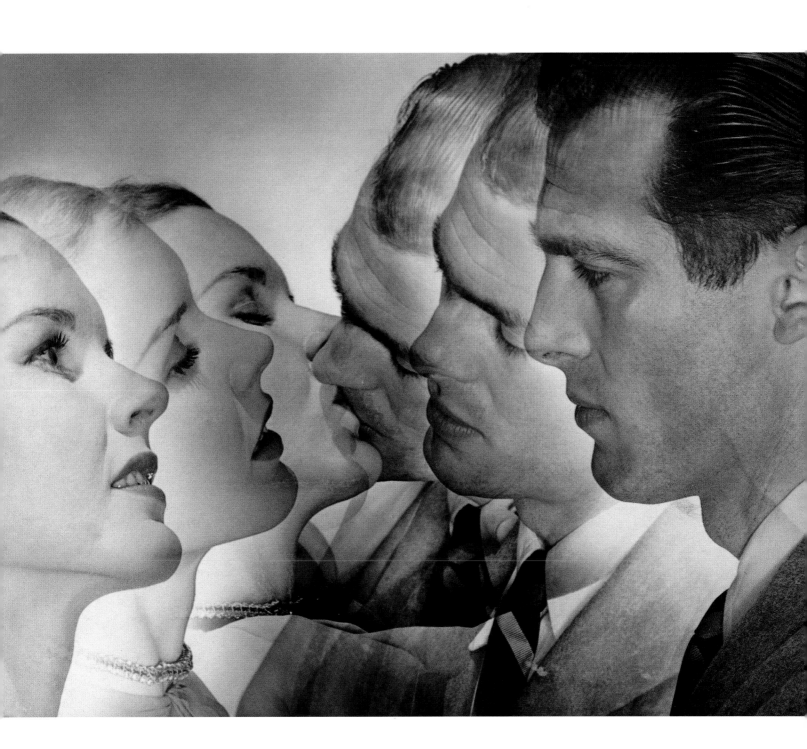

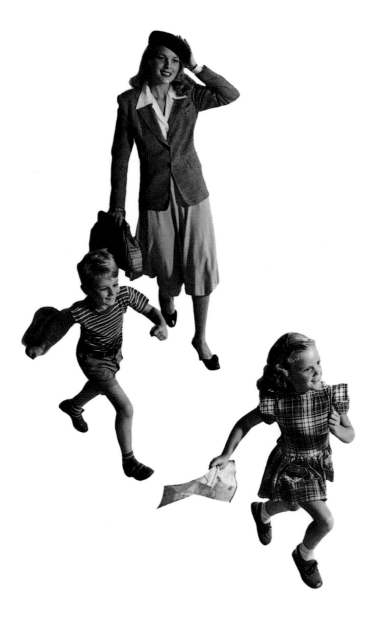
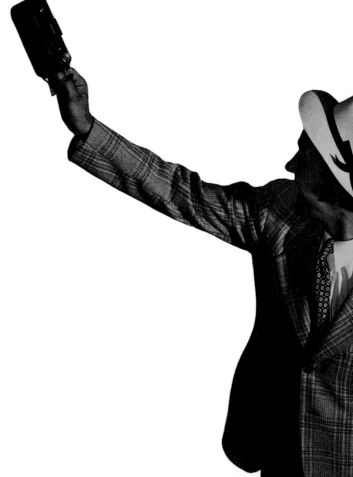

PLATE 108 Eastman Kodak, 1946

CHECKLIST OF THE EXHIBITION

Unless otherwise specified, all works are on loan to the exhibition from the Collection of the Bartholomew Family, courtesy of Keith de Lellis Gallery.

The American Magazine

Plate 96 1949
Gelatin-silver print
10¾ x 10½ in. (27.3 x 26.7 cm)
Los Angeles County Museum of Art,
gift of the Bartholomew Family,
courtesy Keith de Lellis Gallery
AC1998.1.1

Anatomy Ballet Series

Plate 70 Untitled
1950s
Gelatin-silver print
9⅝ x 13⅝ in. (24.4 x 34.6 cm)

Plate 71 Untitled
1950s
Gelatin-silver print
8⅝ x 13⁷⁄₁₆ in. (21.9 x 34.1 cm)
Los Angeles County Museum of Art,
gift of the Bartholomew Family,
courtesy Keith de Lellis Gallery
AC1998.1.27

Band-Aid

Plate 59 c. 1950
Gelatin-silver print
14¹⁄₁₆ x 10³⁄₁₆ in. (35.7 x 26 cm)

Plate 101 c. 1950
Gelatin-silver print
14¹⁄₁₆ x 10³⁄₁₆ in. (35.7 x 26 cm)

Bosco

Plate 8 1951
Gelatin-silver print
10⅝ x 13⁹⁄₁₆ in. (27 x 34.4 cm)

Canada Dry

Plate 56 1954, printed later
Chromogenic-development
print
9⁷⁄₁₆ x 6½ in. (24 x 16.5 cm)

Chesterfield Cigarettes

Plate 58 1950s
Gelatin-silver print
18¹³⁄₁₆ x 13⅝ in. (47.8 x 34.6 cm)

Columbia Records

Plate 14 1946
Gelatin-silver print
8⅜ x 13⅜ in. (21.3 x 34 cm)

Plate 21 1946
Gelatin-silver print
9¹¹⁄₁₆ x 13⁹⁄₁₆ in. (24.6 x 34.4 cm)
Los Angeles County Museum of Art,
gift of the Bartholomew Family,
courtesy Keith de Lellis Gallery
AC1998.1.2

Cosmopolitan Magazine

Plate 18 1948
Gelatin-silver print
13⁹⁄₁₆ x 16⁷⁄₁₆ in. (34.4 x 41.9 cm)
Los Angeles County Museum of Art,
gift of the Bartholomew Family,
courtesy Keith de Lellis Gallery
AC1998.1.3

Plate 107 1940s
Gelatin-silver print
9⁵⁄₁₆ x 12¹³⁄₁₆ in. (23.7 x 32.5 cm)

DuPont

Plate 20 1943
Gelatin-silver print
12¹⁄₁₆ x 12¾ in. (30.6 x 32.4 cm)
Los Angeles County Museum of Art,
gift of the Bartholomew Family,
courtesy Keith de Lellis Gallery
AC1998.1.4

Plate 97 1943
Gelatin-silver print
7⅝ x 9½ in. (19.4 x 24.1)

Eastman Kodak

Plate 1 1948
Gelatin-silver print
13⅜ x 10½ in. (34 x 26.7 cm)
Los Angeles County Museum of Art,
gift of the Bartholomew Family,
courtesy Keith de Lellis Gallery
AC1998.1.10

Plate 6 1954
Chromogenic-development print
15⁷⁄₁₆ x 20 in. (39.2 x 50.8 cm)

Plate 12 1953
Gelatin-silver print
10½ x 13½ in. (26.7 x 34.3 cm)

Plate 15 1950
Gelatin-silver print
13½ x 10½ in. (34.3 x 26.7 cm)

Plate 16 1950
Gelatin-silver print
12¼ x 10⁹⁄₁₆ in. (31.1 x 26.8 cm)

Plate 17 1950
Gelatin-silver print
13½ x 10½ in. (34.3 x 26.7 cm)

Plate 24 c. 1950
Gelatin-silver print
11¹⁄₁₆ x 13¹⁵⁄₁₆ in. (28.1 x 35.4 cm)

Plate 25 1947
Gelatin-silver print
10⁹⁄₁₆ x 10½ in. (26.8 x 26.7 cm)

Plate 26 1949
Gelatin-silver print
13½ x 10⁹⁄₁₆ in. (34.3 x 26.8 cm)

Plate 27	1949 Gelatin-silver print 13½ x 10⁹⁄₁₆ in. (34.3 x 26.8 cm)	*Plate 38*	1947 Gelatin-silver print 9½ x 13½ in. (24.1 x 34.3 cm) Los Angeles County Museum of Art, gift of the Bartholomew Family, courtesy Keith de Lellis Gallery AC1998.1.8
Plate 28	1949 Gelatin-silver print 10¹⁄₁₆ x 13⅜ in. (25.6 x 34 cm)		
Plate 29	1947 Gelatin-silver print 13½ x 10 in. (34.3 x 25.4 cm)	*Plate 39*	c. 1950 Gelatin-silver print 11⁷⁄₁₆ x 14⅛ in. (29.1 x 35.9 cm)
Plate 30	1947 Gelatin-silver print 13¹⁵⁄₁₆ x 11 in. (35.4 x 27.9 cm)	*Plate 40*	1946 Gelatin-silver print 10⁷⁄₁₆ x 14 in. (26.5 x 35.6 cm)
Plate 31	1949 Gelatin-silver print 17¼ x 15⅜ in. (43.8 x 39.1 cm)	*Plate 41*	1947 Gelatin-silver print 10½ x 13⁷⁄₁₆ in. (26.7 x 34.1 cm) Los Angeles County Museum of Art, gift of the Bartholomew Family, courtesy Keith de Lellis Gallery AC1998.1.9
Plate 32	1950 Gelatin-silver print 19⁹⁄₁₆ x 15½ in. (49.7 x 39.4 cm)		
Plate 33	1949 Gelatin-silver print 11⅛ x 10⅝ in. (28.3 x 27 cm)	*Plate 42*	1946 Gelatin-silver print 10⅛ x 13¾ in. (25.7 x 34.9 cm)
Plate 34	1950 Gelatin-silver print 16½ x 13⁷⁄₁₆ in. (41.9 x 34.1 cm)	*Plate 43*	1946 Gelatin-silver print 15⅜ x 19½ in. (39.1 x 49.5 cm) Los Angeles County Museum of Art, gift of the Bartholomew Family, courtesy Keith de Lellis Gallery AC1998.1.12
Plate 35	1949 Gelatin-silver print 13⁷⁄₁₆ x 10½ in. (34.1 x 26.7 cm)		
Plate 36	1952 Gelatin-silver print 13½ x 10⁷⁄₁₆ in. (34.3 x 26.5 cm)	*Plate 44*	1947 Gelatin-silver print 13⅞ x 10⅝ in. (35.2 x 27 cm)
Plate 37	1949 Gelatin-silver print 16¹¹⁄₁₆ x 13⁷⁄₁₆ in. (42.4 x 34.1 cm)		

Plate 45 1950
 Gelatin-silver print
 14 x 10½ in. (35.6 x 26.7 cm)

Plate 46 1946
 Gelatin-silver print
 10⁹⁄₁₆ x 13½ in. (26.8 x 34.3 cm)
 Los Angeles County Museum of Art,
 gift of the Bartholomew Family, courtesy
 Keith de Lellis Gallery
 AC1998.1.11

Plate 47 1947
 Gelatin-silver print
 10⅛ x 14⅛ in. (25.7 x 35.9 cm)
 Los Angeles County Museum of Art,
 gift of the Bartholomew Family, courtesy
 Keith de Lellis Gallery
 AC1998.1.7

Plate 48 c. 1950
 Gelatin-silver print
 10⁷⁄₁₆ x 13⅜ in. (26.5 x 34 cm)

Plate 49 1951
 Gelatin-silver print
 10⁹⁄₁₆ x 13½ in. (26.8 x 34.3 cm)

Plate 50 1947
 Gelatin-silver print
 10¹⁵⁄₁₆ x 14 in. (27.8 x 35.6 cm)

Plate 51 1947
 Gelatin-silver print
 10¹⁵⁄₁₆ x 14¹⁄₁₆ in. (27.8 x 35.9 cm)

Plate 52 1947
 Gelatin-silver print
 16 x 15¹⁄₁₆ in. (40.6 x 38.3 cm)

Plate 54 c. 1950
 Gelatin-silver print
 13⅜ x 10½ in. (34 x 26.7 cm)

Plate 63 c. 1950
 Gelatin-silver print
 13¼ x 10¹⁵⁄₁₆ in. (33.7 x 27.8 cm)

Plate 72 1946
 Gelatin-silver print
 13⁵⁄₁₆ x 16⁵⁄₁₆ in. (33.8 x 41.4 cm)

Plate 99 1954
 Gelatin-silver print
 10½ x 13⁷⁄₁₆ in. (26.7 x 34.1 cm)
 Los Angeles County Museum of Art,
 gift of the Bartholomew Family, courtesy
 Keith de Lellis Gallery
 AC1998.1.6

Plate 103 1953
 Gelatin-silver print
 16½ x 13⅜ in. (41.9 x 34 cm)
 Los Angeles County Museum of Art,
 gift of the Bartholomew Family, courtesy
 Keith de Lellis Gallery
 AC1998.1.5

Plate 108 1946
 Gelatin-silver print
 13⅜ x 9⁷⁄₁₆ in. (34 x 24 cm)

**Electric Light and Power Companies
of America**

Plate 13 1952
 Gelatin-silver print
 13⁷⁄₁₆ x 16½ in. (34.1 x 41.9 cm)
 Los Angeles County Museum of Art,
 gift of the Bartholomew Family, courtesy
 Keith de Lellis Gallery
 AC1998.1.13

Falstaff Brewery

Plate 62 1949
Gelatin-silver print
13½ x 10⁹⁄₁₆ in. (34.3 x 26.8 cm)

Ford Motor Company

Plate 7 1950
Gelatin-silver print
10½ x 13½ in. (26.7 x 34.3 cm)

Fresh Deodorant

Plate 92 1945
Gelatin-silver print
13⁷⁄₁₆ x 14 in. (34.1 x 35.6 cm)
Los Angeles County Museum of Art,
gift of the Bartholomew Family, courtesy
Keith de Lellis Gallery
AC1998.1.14

General Electric

Plate 104 1939, printed 1948
Gelatin-silver print
10⅛ x 12³⁄₁₆ in. (25.7 x 31 cm)
Los Angeles County Museum of Art,
gift of the Bartholomew Family, courtesy
Keith de Lellis Gallery
AC1998.1.15

Goodyear Chemical Division

Plate 53 c. 1947, printed later
Chromogenic-development print
10⁷⁄₁₆ x 12⅝ in. (26.5 x 32.1 cm)

Harper's Bazaar **Magazine**

Plate 85 1946
Gelatin-silver print
10⁷⁄₁₆ x 13⁹⁄₁₆ in. (26.5 x 34.4 cm)

Plate 87 1946
Gelatin-silver print
13 x 10¼ in. (33 x 26 cm)

Plate 88 1946
Gelatin-silver print
17⁵⁄₁₆ x 14½ in. (44 x 36.8 cm)

Plate 89 1946
Gelatin-silver print
10⁷⁄₁₆ x 9⁵⁄₁₆ in. (26.5 x 23.7 cm)

Hires Root Beer

Plate 22 1950
Gelatin-silver print
7¾ x 13⁷⁄₁₆ in. (19.7 x 34.1 cm)
Los Angeles County Museum of Art,
gift of the Bartholomew Family, courtesy
Keith de Lellis Gallery
AC1998.1.16

Inco Nickel

Plate 60 1960
Chromogenic-development print
10⁷⁄₁₆ x 11⅝ in. (26.5 x 29.5 cm)
Los Angeles County Museum of Art,
gift of the Bartholomew Family, courtesy
Keith de Lellis Gallery
AC1998.1.17

Kaiser-Frazer

Plate 64 1949
Gelatin-silver print
10⁹⁄₁₆ x 13¾ in. (26.8 x 34.9 cm)

Plate 65 1949
Gelatin-silver print
9⅜ x 13¾ in. (23.8 x 34.9 cm)

Plate 66 1949
Gelatin-silver print
9⁹⁄₁₆ x 13¹¹⁄₁₆ in. (24.3 x 34.8 cm)

Keetman and Sons

Plate 93 1939
Gelatin-silver print
14³⁄₁₆ x 10 in. (36 x 25.4 cm)

Model tests

Plate 90 1951
Gelatin-silver print
10 x 13⁹⁄₁₆ in. (25.4 x 34.4 cm)

Plate 91 1951
Gelatin-silver print
9⅝ x 13⅝ in. (24.4 x 34.6 cm)
Los Angeles County Museum of Art,
gift of the Bartholomew Family, courtesy
Keith de Lellis Gallery
AC1998.1.25

Pepsi-Cola

Plate 4 1950
Gelatin-silver print
10⅜ x 13⁷⁄₁₆ in. (26.4 x 34.1 cm)

Plate 23 c. 1950
Gelatin-silver print
11¹⁵⁄₁₆ x 14¹¹⁄₁₆ in. (30.3 x 37.3 cm)

Plate 55 c. 1950
Gelatin-silver print
15¼ x 16⁷⁄₁₆ in. (38.7 x 41.8 cm)

Pepsodent

Plate 57 1950
Gelatin-silver print
13⁷⁄₁₆ x 10½ in. (34.1 x 26.7 cm)

Playtex

Plate 9 1950
Gelatin-silver print
10½ x 13⁷⁄₁₆ in. (26.7 x 34.1 cm)

Plate 10 1950
Gelatin-silver print
10½ x 13⁷⁄₁₆ in. (26.7 x 34.1 cm)

Plate 69 c. 1950
Gelatin-silver print
7½ x 9⁷⁄₁₆ in. (19.1 x 24 cm)
Los Angeles County Museum of Art,
gift of the Bartholomew Family, courtesy
Keith de Lellis Gallery
AC1998.1.22

Plate 73 1954
Gelatin-silver print
9⅛ x 12 in. (23.2 x 30.5 cm)

Plate 74 1950
Gelatin-silver print
11¹¹⁄₁₆ x 16⁷⁄₁₆ in. (29.7 x 41.8 cm)

Plate 75 1952
Gelatin-silver print
12 x 16½ in. (30.5 x 41.9 cm)

Plate 76 c. 1950
 Gelatin-silver print
 10 15⁄16 x 13 11⁄16 in. (27.8 x 34.8 cm)
 Los Angeles County Museum of Art,
 gift of the Bartholomew Family, courtesy
 Keith de Lellis Gallery
 AC1998.1.21

Plate 79 1953
 Gelatin-silver print
 13 7⁄16 x 8 7⁄16 in. (34.1 x 21.4 cm)

Plate 80 1951
 Gelatin-silver print
 10 13⁄16 x 16 7⁄16 in. (27.5 x 41.8 cm)
 Los Angeles County Museum of Art,
 gift of the Bartholomew Family, courtesy
 Keith de Lellis Gallery
 AC1998.1.20

Plate 81 1950
 Gelatin-silver print
 12 5⁄16 x 16 7⁄16 in. (31.3 x 41.8 cm)

Plate 82 c. 1950
 Gelatin-silver print
 8 13⁄16 x 13 1⁄2 in. (22.4 x 34.3 cm)

Plate 83 1950
 Gelatin-silver print
 12 1⁄8 x 16 1⁄2 in. (30.8 x 41.9 cm)
 Los Angeles County Museum of Art,
 gift of the Bartholomew Family, courtesy
 Keith de Lellis Gallery
 AC1998.1.19

Plate 84 1946
 Gelatin-silver print
 7 15⁄16 x 14 3⁄8 in. (20.2 x 36.5 cm)

Plate 86 1950
 Gelatin-silver print
 10 7⁄16 x 14 1⁄16 in. (26.5 x 35.7 cm)

Plate 102 1940s
 Gelatin-silver print
 7 15⁄16 x 10 5⁄8 in. (20.2 x 27 cm)
 Los Angeles County Museum of Art,
 gift of the Bartholomew Family, courtesy
 Keith de Lellis Gallery
 AC1998.1.18

Science Illustrated Magazine

Plate 68 1946
 Gelatin-silver print
 14 1⁄2 x 10 1⁄8 in. (36.8 x 25.7 cm)

Sunshine Biscuit

Plate 61 1953
 Gelatin-silver print
 10 3⁄16 x 13 3⁄8 in. (25.9 x 34 cm)
 Los Angeles County Museum of Art,
 gift of the Bartholomew Family, courtesy
 Keith de Lellis Gallery
 AC1998.1.23

Texaco

Plate 11 1940
 Gelatin-silver print
 10 3⁄16 x 11 1⁄4 in. (25.9 x 28.6 cm)
 Los Angeles County Museum of Art,
 gift of the Bartholomew Family, courtesy
 Keith de Lellis Gallery
 AC1998.1.24

Plate 67 1957
 Dye-imbibition print
 12 7⁄8 x 19 3⁄8 in. (32.6 x 49.1 cm)
 International Museum of Photography at
 George Eastman House

Plate 94 1940
 Gelatin-silver print
 13 1⁄4 x 17 1⁄8 in. (33.7 x 43.5 cm)

Plate 95	1940	**Whitman Candies**
	Gelatin-silver print	
	11⁹⁄₁₆ x 14³⁄₁₆ in. (28.4 x 36 cm)	*Plate 2* 1937
		Gelatin-silver print
Plate 105	1940	10⁵⁄₁₆ x 12½ in. (26.2 x 31.8 cm)
	Gelatin-silver print	Los Angeles County Museum of Art,
	14⁷⁄₁₆ x 16⅞ in. (36.7 x 42.9 cm)	gift of the Bartholomew Family, courtesy
		Keith de Lellis Gallery
		AC1998.1.26

Unknown client

Plate 3 c. 1940
Gelatin-silver print
10⅝ x 13⁷⁄₁₆ in. (27 x 34.1 cm)

Plate 5 1936
Gelatin-silver print
13¹⁄₁₆ x 10¼ in. (33.2 x 26 cm)

Plate 19 c. 1945
Gelatin-silver print
10¹⁄₁₆ x 12⅞ in. (25.6 x 32.7 cm)

Plate 98 1940s
Gelatin-silver print
5¹⁵⁄₁₆ x 13⁷⁄₁₆ in. (15.1 x 34.1 cm)

Plate 100 1940s
Gelatin-silver print
8 x 11 in. (20.3 x 27.9 cm)

Plate 106 1940s
Gelatin-silver print
9¹⁵⁄₁₆ x 9⅜ in. (25.2 x 23.8 cm)

Vision Nylons

Plate 77 1940s
Gelatin-silver print
10⁷⁄₁₆ x 13½ in. (26.5 x 34.3 cm)

Plate 78 1940s
Gelatin-silver print
10½ x 13½ in. (26.7 x 34.3 cm)

ACKNOWLEDGMENTS

I first encountered the photography of Ralph Bartholomew Jr. while working on the exhibition *The Camera I: Photographic Self-Portraits from the Audrey and Sydney Irmas Collection.* Bartholomew's image would grace the catalogue's cover, and I was intrigued by the man behind the flash. I discovered in him a photographer whose work and reputation was defined by the artificial light he had included in his self-portrait. That discovery and a chance meeting in New York began a three-year process that culminated in *Retail Fictions.* This project has given me the opportunity to collaborate with a widely diverse group of generous, creative, and committed people, all of whom have left an imprint on the final outcome and upon me.

First I would like to acknowledge the Bartholomew family: Mrs. Helen Bartholomew, Ralph Bartholomew III, and Edward and Margaret Bartholomew. Their hospitality and willingness to share their feelings, memories, and histories to a total stranger provided a rich source of information and anecdote. Second, but by no means secondarily, I would like to thank Keith de Lellis, who almost single-handedly kept the awareness of Bartholomew's photography alive and without whom this project might never have begun. His expertise and insights have contributed immeasurably to both the exhibition and catalogue.

I have the pleasure and privilege of working with colleagues at the Los Angeles County Museum of Art who are talented, supportive, and able to bring out the best in each other. *Retail Fictions* has been the beneficiary of their spirited camaraderie. Special thanks are due editor Chris Keledjian, designer Scott Taylor, photographer Steve Oliver, registrars Jennifer Weber and Sandy Davis, and conservators Victoria Blythe-Hill and Narelle Jarry. Most notable, however, is Eve Schillo, departmental secretary and coconspirator, to whom I am grateful for her perspective, humor, expertise, and ability to instill fresh life into flagging spirits.

Many friends have contributed intellectual and moral support to see this project to completion. Special acknowledgments are due to Mariana and Tony Amatullo, Gordon Baldwin, Fred Croton, Tom Gilman, Michael Goyak and John Donahue, Deborah Irmas, Michael Maloney, Martha Neighbors and Charles Boday, Cameron Whiteman, and the members of the Photography Arts Consortium.

Finally, I would like to thank three people, mentors and friends all, from whom I have learned much and to whom I dedicate this effort: Richard Brustlin, who gave me an understanding of unlimited possibilities; Selma Holo, whose unflagging energies, boundless curiosity, and generosity of spirit are an inspiration; and Robert Sobieszek, who has given so freely of his knowledge, counsel, and encouragement.

TIM B. WRIDE

Assistant Curator of Photography
Los Angeles County Museum of Art

146

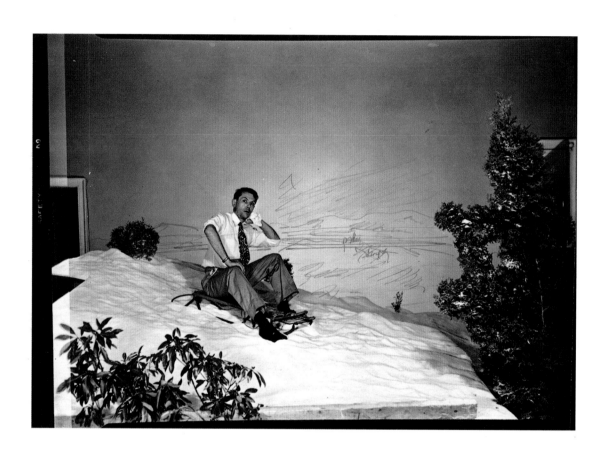

Ralph Bartholomew Jr. at work in his studio, c. 1950